THE ART OF THE FORGER

Christopher Wright

The Art of the Forger

Dodd, Mead & Company • New York

First published in the United States in 1985
Copyright © 1984 by Christopher Wright
All rights reserved
No part of this book may be reproduced in any form
without permission in writing from the publisher.
Published by Dodd, Mead & Company, Inc.
79 Madison Avenue, New York, N.Y. 10016
Manufactured in the United States of America

First Edition

First published in 1984 in the United Kingdom by the
Gordon Fraser Gallery Ltd, London and Bedford.

Library of Congress Cataloging in Publication Data

Wright, Christopher, 1945—
 The art of the forger.

 Includes index.
 1. La Tour, Georges du Mesnil de, 1593-1652.
Fortune teller. 2. Painting—Forgeries. 3. Painting—
Expertising. I. Title.
ND553.L28A648 1985 759.4 84-18760
ISBN 0-396-08568-7

Illustrations originated by Westerham Press, Westerham, Kent
Designed by Peter Guy

CONTENTS

ACKNOWLEDGEMENTS

IF I ACKNOWLEDGE by name any of the distinguished people who have helped me during the years of research on this book it may look as if they agree with what I say. I would not like to place any museum official or scholar in such an invidious position but I am nevertheless grateful to them all. I am, however, especially grateful to Simon Kingston, who tactfully but firmly guided me through the labyrinthine process of collating the information used in this book. Robin Moray provided invaluable technical help.

I feel free to acknowledge my publishers as they have given me every encouragement in a difficult task – that of saying what I think. The late Benedict Nicolson summed it up perfectly when he was writing about the then elusive Terbrugghen . . . 'I have tried to say what I think and not cover up unkindnesses by elegance; tact and urbanity are the enemies of scholarship.'

CHRISTOPHER WRIGHT
Temple Normanton,
Derbyshire

FOR
MICHAEL YOUNG

INTRODUCTION

WE ONLY HAVE TO LOOK into the very recent past to see how the great figures of the art establishment were made a laughing stock by the devious ingenuity of the forger Han van Meegeren. Not only was the most distinguished scholar of Dutch painting, Abraham Bredius, responsible for publishing van Meegeren's *Supper at Emmaus* (in *The Burlington Magazine*) as a Vermeer, but Bredius in turn influenced a younger generation of art historians. A. B. De Vries, subsequently director of The Mauritshuis in The Hague, included the van Meegerens in his book on Vermeer, and had to remove them from the second edition. So great was the shock, these highly significant changes were passed over in silence.

It is indeed important to note that following the exposure of van Meegeren (on his own admittance), there has been no proper enquiry as to how the deception could have fooled the experts. The existing literature concentrates solely on the forger's methods and the techniques of exposing him.

In the case of the dubious La Tour which opens this book the problem is yet more embarrassing than for van Meegeren's 'Vermeers'. This is because the 'La Tour' contains the elements of a hoax. In other words the Metropolitan Museum and all the art historians who published the picture as authentic, including myself, fell into the same trap that rocked the art establishment in the years just after the second world war.

GEORGES DE LA TOUR
(Vic-sur-Seille 1593 – Lunéville 1652)

THIS SECTION documents and reproduces all the pictures by La Tour, and those attributed to his son and imitator, Etienne. The disputed 'daylight' pictures and the forgeries will be seen to stand out in stark contrast.

The facts of La Tour's life as so far known are scant indeed. Pictures which can be attributed to him with a reasonable degree of certainty number less than twenty. This is how these facts became known.

1863 The Municipal archivist of Lunéville, M. Alexandre Joly, discovered and published a series of payments made by the town of Lunéville during the years 1644–52 to a then unknown and unidentified painter, Georges de La Tour. The high prices paid for the pictures by the town indicated that the painter must have been of some importance.

1899 Parts of the municipal registers of Lunéville were published and this established that La Tour had lived in the town for some thirty years.

1915 Herman Voss, the distinguished German scholar, wrote an article in an obscure German periodical which identified some three pictures and one engraving which could be attributed to La Tour. They were found, as might have been expected, in French provincial museums.

1934 Charles Sterling organised (in the Orangerie at Paris), an exhibition of French seventeenth-century painting in which some twelve pictures were attributed to La Tour.

1972 An exhibition of La Tour's work in the Orangerie, with Sterling included on the committee, showed that the number of pictures attributed to La Tour had risen to almost forty, not including copies and disputed versions.

The facts concerning the artist's career as a painter are these:

1593 La Tour was born in Vic-sur-Seille, then a small fortified town in the bishopric of Metz (an independent bishopric within The Empire but under French control). He was the son of a baker.

1616 La Tour is recorded in Vic as having acted as a godfather.

1617 La Tour marries Diane Le Nerf, the daughter of a bourgeois of Lunéville, which is some twenty miles away, in the duchy of Lorraine.

1620 La Tour, describing himself as a painter, seeks permission from the Duke of Lorraine to move to Lunéville where he wishes to be exempt from taxes. In this petition he notes that one of the reasons for moving to Lunéville is that there are *no other painters active in the town or its environs* (*'Ny ayant la ny aux environs personne de l'art et profession du Remonstrant'*).

1623 An unidentified picture is recorded as having been bought by the Duke of Lorraine at Nancy for a small sum.

1624 A *St Peter* is recorded in the collection of the Duke of Lorraine at Nancy. The price paid was low.

1620s La Tour is recorded as having taken apprentices into his studio. He continues to act as a godfather and becomes involved in property transactions. There is no record at this time of the type of pictures he painted.

c.1630 It is likely, based on the evidence of the 1634 *Payment of Dues* in Lvov, that *Peasant woman* and *Peasant man* survive from La Tour's hand as his earliest works apart from the Hampton Court *St Jerome*. Both pictures can be related, in terms of their handling, to the Lvov work.

1634 The earliest surviving signed and dated picture, *The Payment of Dues*. The earlier pictures are attributions based on stylistic associations.

early From this period survive three enigmatic engravings
1630s which have puzzled all La Tour specialists. Either without caption or with spurious 'Callot' inscriptions they have been attributed to Jean Le Clerc, the court painter at Nancy who died in 1633. The source of this

attribution is the fact that a fourth engraving, clearly by the same hand, is after Le Clerc's *Concert Party*, a picture in the Gallery at Schleissheim, near Munich. Significantly all three engravings have compositions related to them which have been attributed to La Tour.

1630s All the specialists on La Tour are in agreement about placing the pictures shown on pp. 20–22 in the 1630s.

late It is likely that La Tour painted two versions of *St*
1630s *Sebastian* at about this time (and a third for Lunéville later). The evidence for this is a mid-eighteenth-century source which states that La Tour painted a *St Sebastian* for Louis XIII of France which the king liked so much that he caused all other pictures to be removed from the room. The same source states that the artist had also painted 'another' for the Duke of Lorraine. On stylistic grounds neither of the *two* compositions surviving can be convincingly placed at this time. The reason for assuming that the document refers to this time is that Louis XIII died in 1643 and was last in Lorraine in the late 1630s.

1640s By general consensus the period of La Tour's maturity: what is considered by many to be his finest picture (*The New-Born* at Rennes) has been placed in this period.

1644 The first of the payments by the town of Lunéville for a *Nativity of Our Saviour*. Most authorities have identified this as the Louvre picture (p. 28, top). This picture is close in treatment to the dated *Penitent St Peter* of 1645.

1645 The second dated picture essential for the reconstruction of La Tour's final period (*The Penitent St Peter* at Cleveland, p. 29).

1649 Further payments to La Tour by the town of Lunéville for two pictures: a *St Alexis* and a *St Sebastian*. There are two versions of the *St Alexis*, one slightly better than the other (Nancy superior to Dublin) and two of the upright composition of the *St Sebastian* (Louvre being superior to Berlin-Dahlem, Staatliche Gemälde-galerie) and no less than eleven versions of the horizontal *St Sebastian* of which at least three can claim to be of some quality. The one showing the

largest number of changes during execution is that in the Ottavio Poggi Collection. All these pictures may well have been executed on La Tour's designs by Etienne de La Tour. A document of 1646 specifically states that in the event of La Tour's death his art was to be continued *'sur les mesmes precepts'* [on the same lines].

1650 La Tour's third dated picture (pp. 30–31) demonstrates a certain decline in skill as he reached his late fifties (*The Denial of Peter*, Nantes).

1651 The Lunéville accounts record the payment to La Tour for a *Denial of Peter*. It is difficult to avoid the conclusion that the Nantes picture is the one mentioned.

c.1651 What is probably the artist's last picture (*The Dice Players*, pp. 32–3), on the basis of its similarities with the Nantes *Denial of Peter*.

1652 The death of both La Tour and his wife in January (deaths recorded in the parish registers of Lunéville). La Tour's reputation seems to have slid into immediate obscurity. However from the following year an extremely important document is recorded, although the original was destroyed in the fire which annihilated all the archives of Orléans in 1940. The pictures paid for by Lunéville had all been presented by the town to the French Governor at Nancy, the Marquis de La Ferté. His pictures were inventoried by Claude Deruet who had worked extensively for the Nancy Ducal Court. Deruet's valuations were much lower than the prices Lunéville had paid for the pictures. Crucially, *all* the pictures were described as being 'en nuict'. Therefore *all* La Tour's documented pictures are clearly night scenes with the exception of the *St Peter* for the Duke of Lorraine in 1624. *All* La Tour's documented pictures are also of religious subjects. *All* the 'genre' scenes which I consider to be authentic can also have religious connotations. The *Dice Players* could well be the soldiers gambling for Christ's clothes watched over by the serving maid, forming a sequel to the *Denial of Peter*.

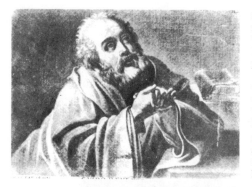

(left) *The Penitent St Peter*, mezzotint. A lost picture recorded in the collection of the Archduke Leopold Wilhelm in Brussels in 1659 and later in Vienna. 16.1 × 22.4 cm. The original canvas was probably 55.2 × 73.6 cm.

(far right) *Peasant woman*. Entirely unknown until *c.* 1940. Published by Vitale Bloch in 1954. 90.5 × 59.5 cm. De Young Museum, San Francisco.

(right) *Peasant man*. Entirely unknown until *c.* 1940. Published by Vitale Bloch in 1954. 90.5 × 59.5 cm. De Young Museum, San Francisco.

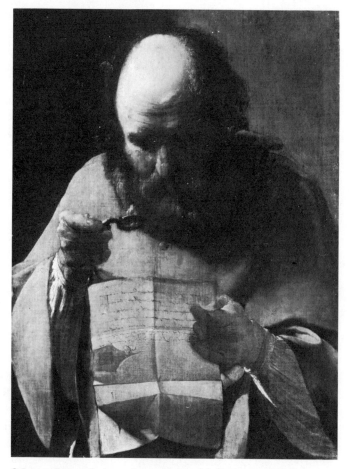

St Jerome. Picture first recorded in the Royal Collection in 1660 then attributed to Dürer. 62.2 × 47.1 cm. Royal Collection, Hampton Court Palace. Reproduced by gracious permission of Her Majesty the Queen.

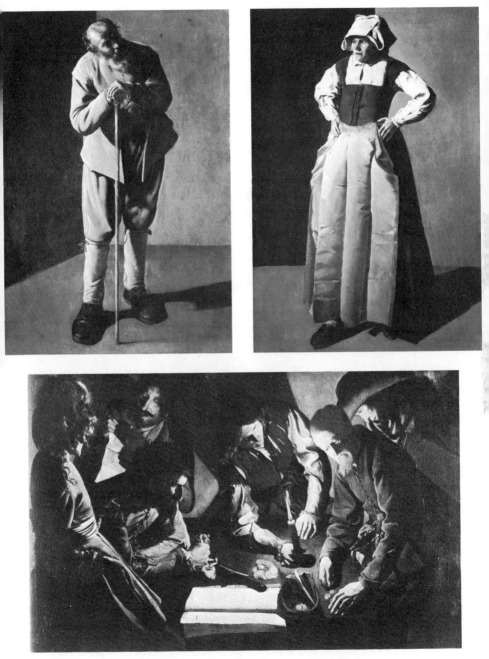

The Payment of Dues. Signed and dated centre left: G. de La Tour 1634. First recorded at Lvov early nineteenth century. Identified as La Tour 1972. 99 × 152.5 cm. Lvov Museum, USSR.

The Two Monks, engraving. 24 × 31 cm.

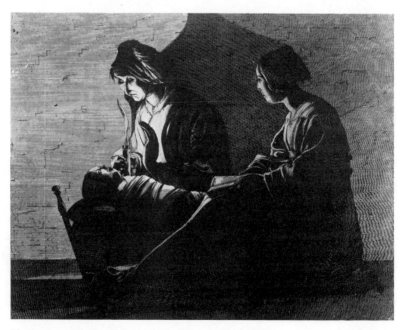

The Virgin and Child with St Anne, engraving. 26.7 × 33.2 cm.

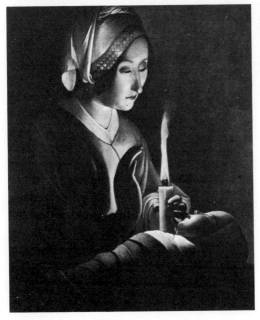

The Two Monks. Two copies known. First recorded in the museum in 1892; attributed to La Tour in 1934; attribution now doubted by most specialists. 154 × 163 cm. Musée de Tessé, Le Mans.

St Anne, fragment. First recorded as with Wildenstein in 1942. 66 × 55 cm. Vaughan Collection, Montreal.

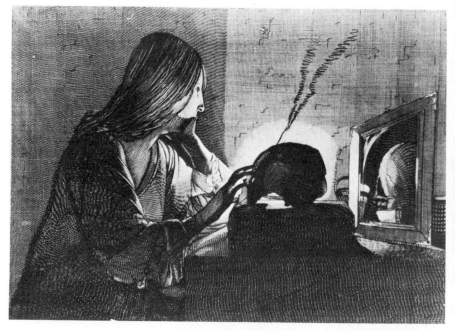

The Magdalen, engraving. 20.4 × 27.5 cm.

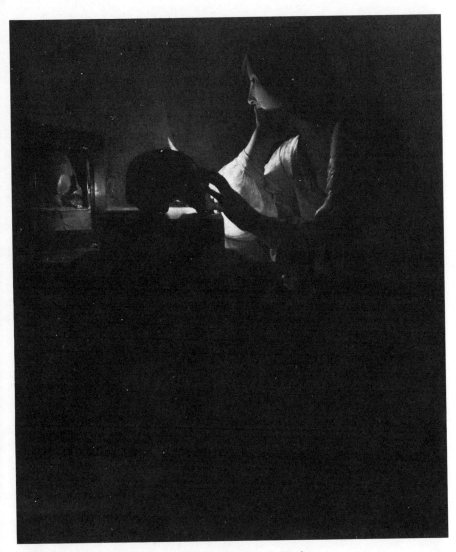

The Magdalen. First recorded 1877; identified as a La Tour by Sterling 1937. 113 × 93 cm. National Gallery, Washington.

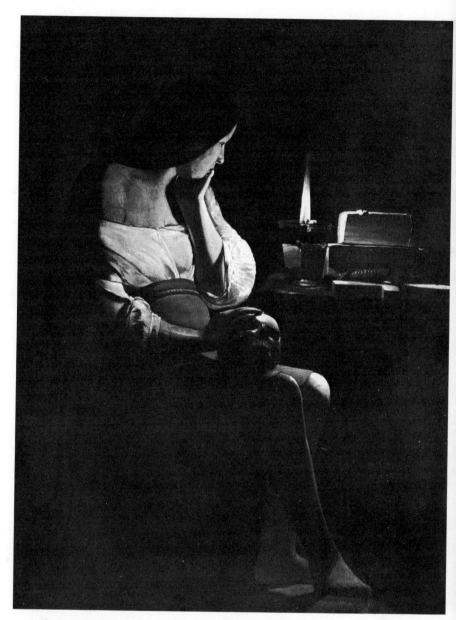

The Magdalen. Signed centre right: La Tour fecit. First recorded 1914;
identified as La Tour 1938. 128 × 94 cm. Musée du Louvre, Paris.

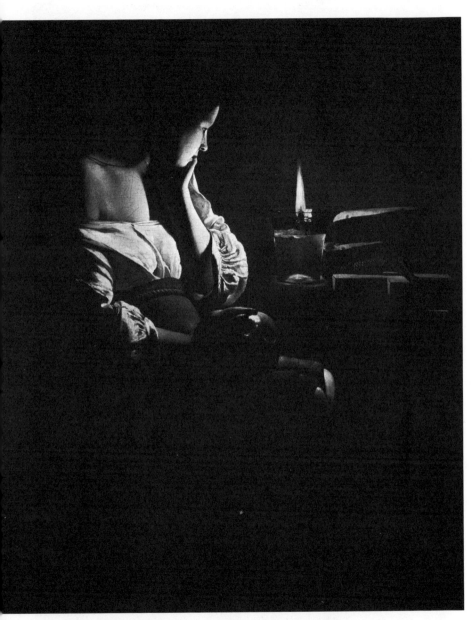

The Magdalen. Signed lower right: G. de La Tour f. First discovered and identified as La Tour 1972. 118 × 90 cm. County Museum, Los Angeles.

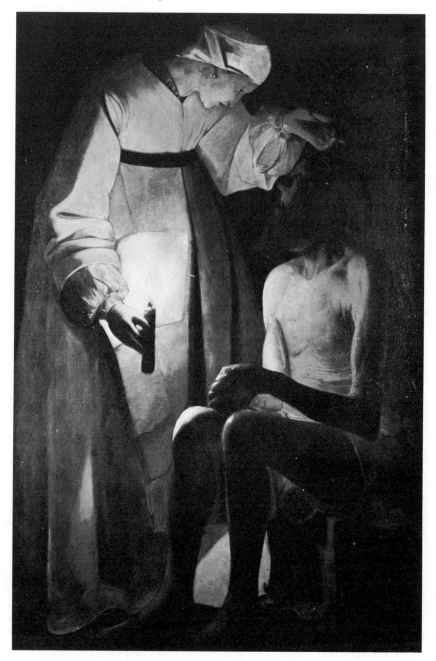

Job Mocked by his Wife. Signed along the bottom; G... de La Tour fec. First recorded in 1825; entered the museum 1829; first attributed to La Tour 1922. 114 × 95 cm. Musée Départemental des Vosges, Epinal.

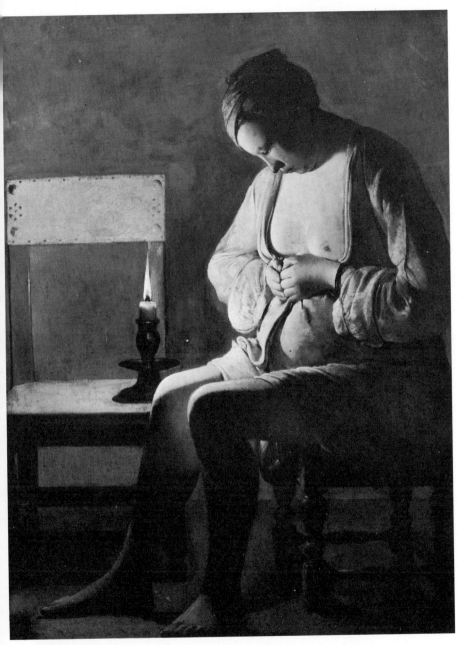

The Woman with the Flea. Possibly first recorded in 1929; acquired by the museum 1955. 120 × 90 cm. Musée Historique Lorrain, Nancy.

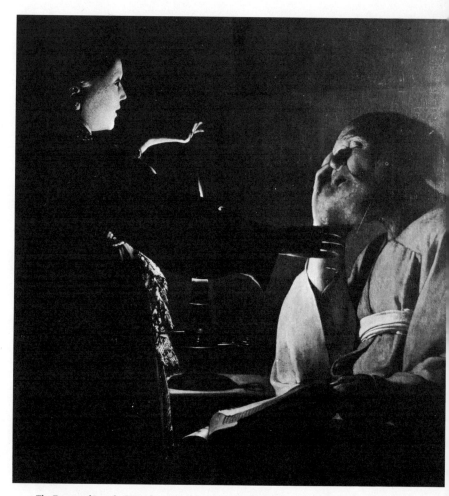

The Dream of Joseph. Signed upper right: G. de La Tour f. First recorded in the museum in 1810; identified as by La Tour by Voss in 1915. 93 × 81 cm. Musée des Beaux-Arts, Nantes.

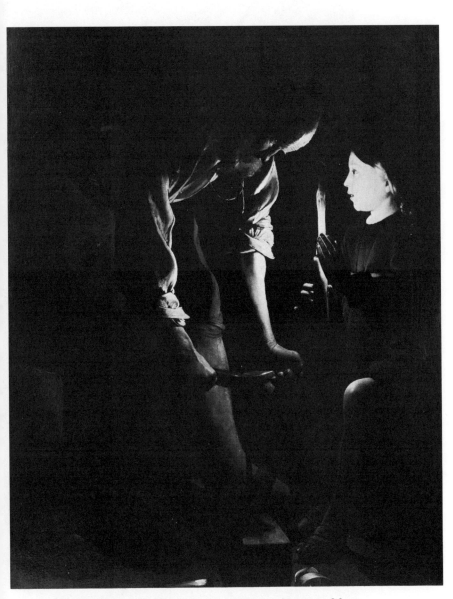

Christ in the Carpenter's Shop. First recorded *c*. 1938; purchase turned down
by the National Gallery, London; given to the Louvre in 1948.
137 × 101 cm. Musée du Louvre, Paris.

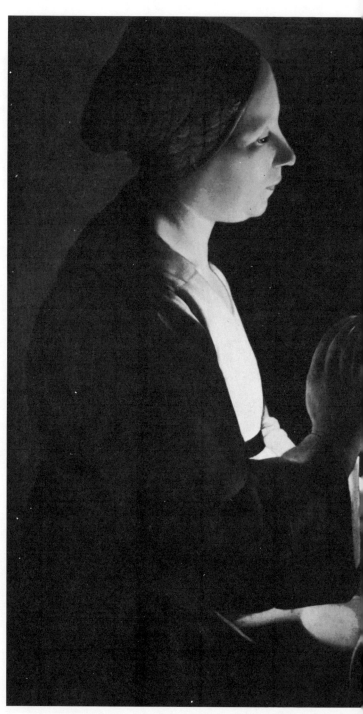

The New-born. First recorded in the museum 1794; identified as by La Tour

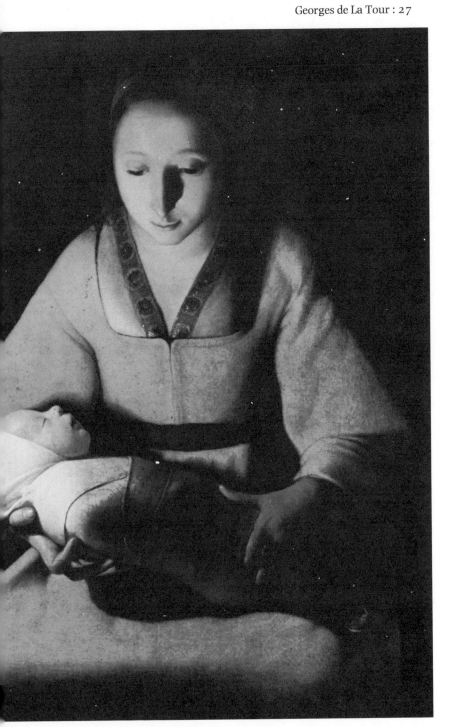

by Voss in 1915. 76 × 91 cm. Musée des Beaux-Arts, Rennes.

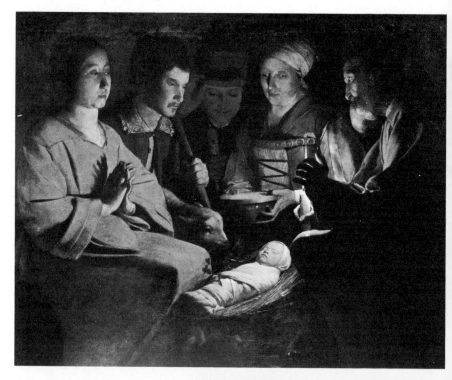

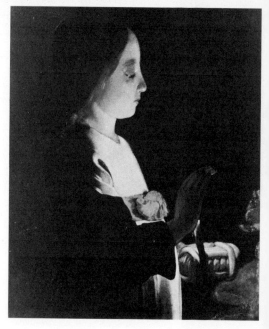

The Adoration of the Shepherds. Discovered and identified as La Tour by Vitale Bloch in 1926. 106.5 × 131 cm. Musée du Louvre, Paris.

The Education of the Virgin. Whole composition known from a copy; fragment first recorded 1934. 57 × 45 cm. Institute of Arts, Detroit.

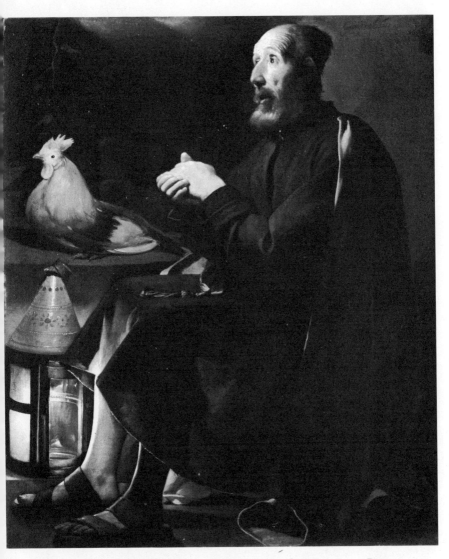

The Penitent St Peter. Signed and dated upper right: Georges de La Tour Inv. et Pinx.
1645. First identified as La Tour in 1951; earlier history not revealed.
114.6 × 94.9 cm. Museum of Art, Cleveland, Ohio.

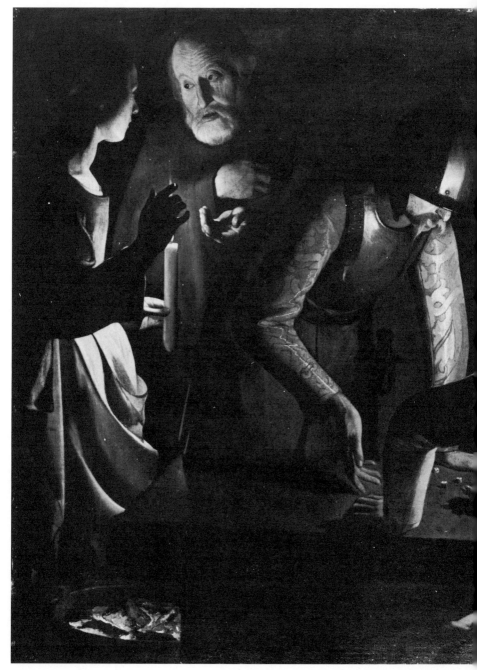

The Denial of Peter. Signed and dated along the edge of the table: Georges de La Tour In. et. Fe. M.D.C.L. (1650). First

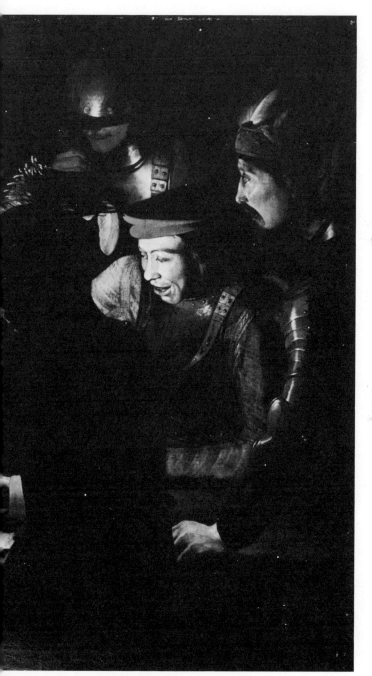

recorded in the museum 1810; identified as La Tour by
Voss in 1915. 120 × 160 cm. Musée des Beaux-Arts, Nantes.

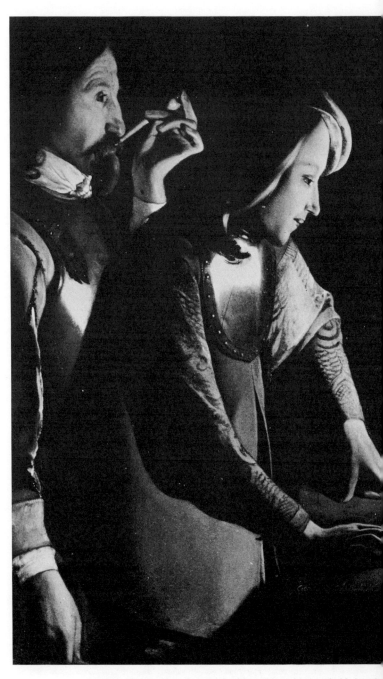

The Dice Players. Signed along the edge of the table in a feeble hand: Georges de La Tour, Inv. e Pinx. Possibly recorded as early as 1842

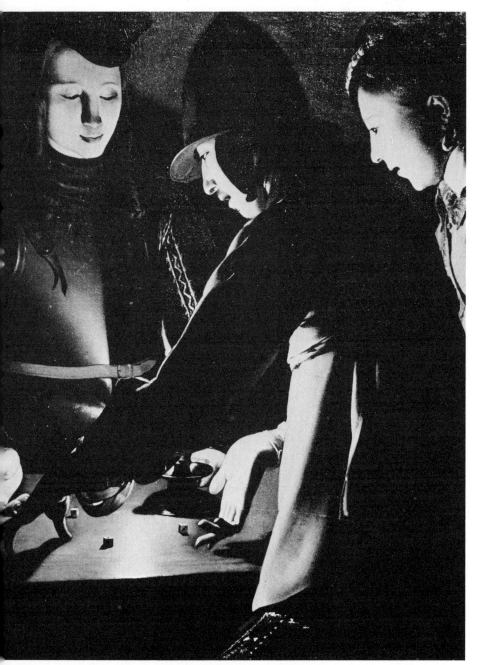

st certainly recorded 1930; identified as by La Tour 1972.
2.5 × 130.5 cm. Preston Manor, Stockton-on-Tees, County Durham.

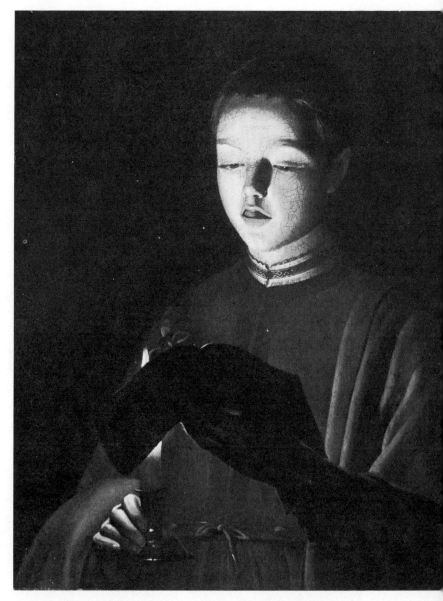

The Choirboy. First recorded in the collection of the custodian of the pictures at Hampton Court *c.* 1900. Identified as by La Tour and bought by the Museum 1984. 66.7 × 50.2 cm. Leicestershire County Museum. Here published for the first time.

ETIENNE DE LA TOUR
AND THE STUDIO OF GEORGES DE LA TOUR

ETIENNE DE LA TOUR was born in 1621 in Lunéville and in 1646 reached the age of majority – thus allowing him to sign documents. His signature appears on occasion alongside that of his father. It is usually De La Tour. It is known that La Tour trained Etienne to be a painter. Only one picture bears Etienne's signature as found on the documents: *The Education of the Virgin*, p. 36.

The next group of pictures (on pp. 36–7) is signed either La Tour or De la Tour. All of them have been doubted by one or other authority as being good enough for La Tour. In my opinion they could either be late works by La Tour or early works by Etienne. The signatures are of no help.

The pictures on pp. 38–43, although unsigned, are La Tour compositions. Stylistically they fit into La Tour's last years, although Diana de Marly dates all the *St Sebastian* compositions to the 1660s, which would mean that they would all have to be by Etienne de La Tour.

These compositions are likely to reflect the picture documented in 1649.

THE HURDY-GURDY MASTER

The group of authentic pictures shown on pp. 44–6 began to be attributed to La Tour only after the appearance of the Louvre *Cheat*. They form a coherent group and were painted by an artist of great ability, though not by La Tour. At no stage have any of them been documented as by La Tour and none are signed. They are listed under the year in which they were first recorded

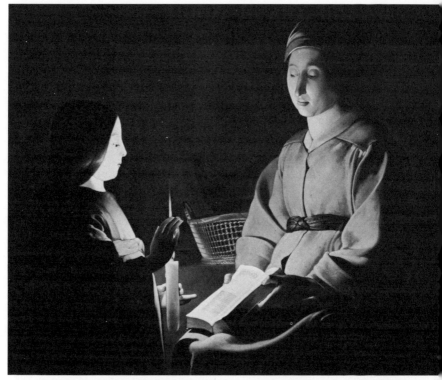

The Education of the Virgin. Signed centre left: De La Tour f. First recorded 1940s; three inferior versions known, Paris Private Collection, Switzerland Private Collection and Dijon, Musée des Beaux-Arts. 83.3 × 100 cm. Frick Collection, New York.

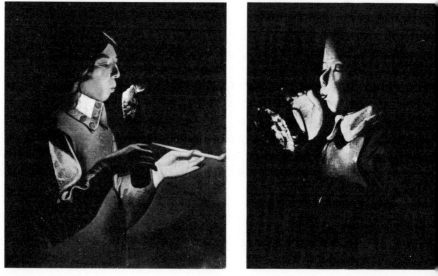

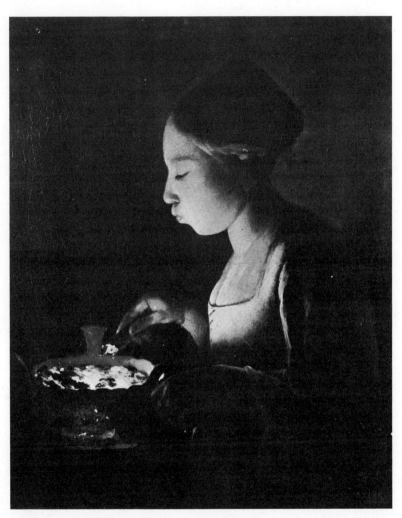

(above) *The Girl with the Brazier*. Signed upper right: ... a Tour ... First recorded 1950s; versions in several private collections. 65 × 55 cm. Private Collection, Bremen.

(far left) *The Smoker*. First identified 1973; versions in Nancy, Musée Historique Lorrain and in three private collections, one of which is signed. 71 × 62 cm. St Louis Art Museum.

(left) *Boy Blowing on a Charcoal Stick*. Signed upper right: de La Tour f. First discovered *c*. 1960. 61 × 51 cm. Musée des Beaux-Arts, Dijon.

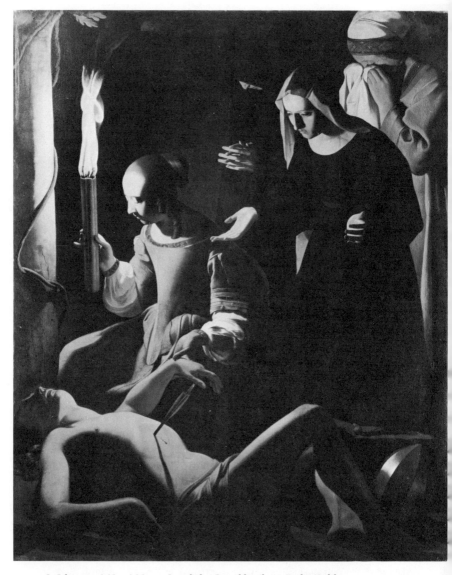

St Sebastian. 162 × 129 cm. Staatliche Gemäldegalerie, Berlin-Dahlem.

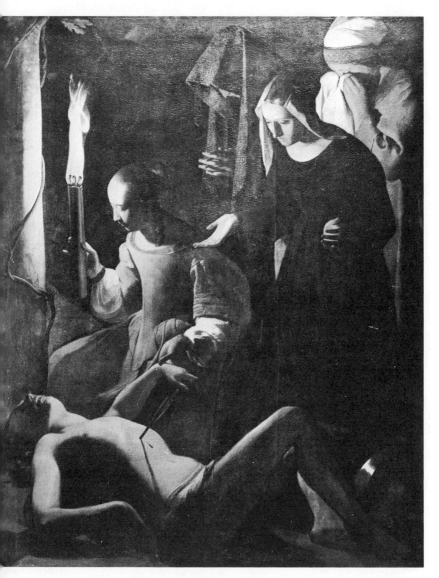

St Sebastian. 167 × 130 cm. Musée du Louvre, Paris.

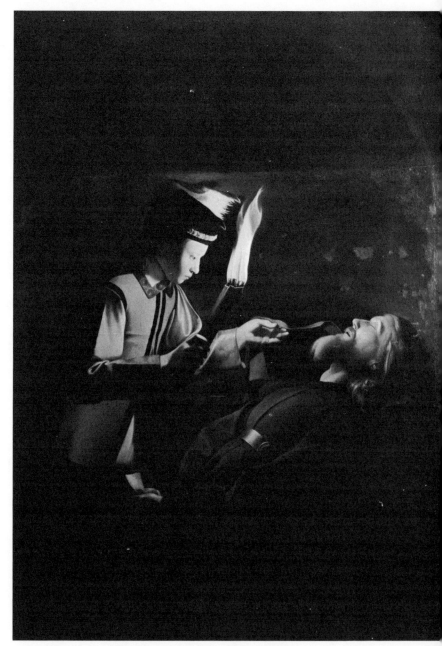

St Alexis. 158 × 115 cm. Musée Historique Lorrain, Nancy.

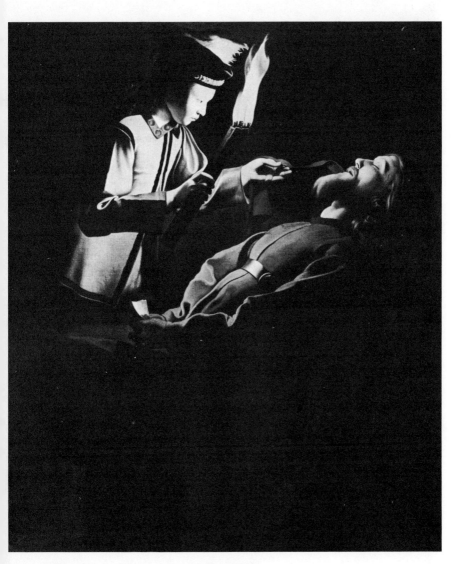

St Alexis. 143.5 × 117 cm. National Gallery, Dublin.

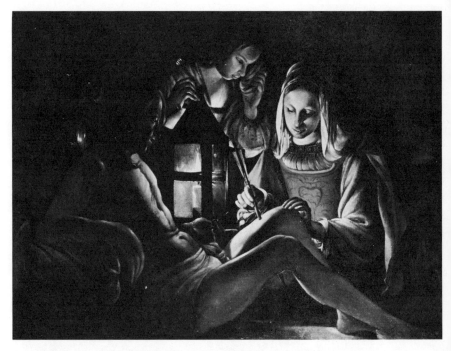

St Sebastian. 102 × 136 cm. Ottavio Poggi Collection, Rome.

(above right) *St Sebastian.* 104 × 136 cm. Private Collection, Paris.

(right) *St Sebastian.* No dimensions available. With Wildenstein.

St Sebastian. Other versions are to be found:

46 × 55 cm.	Paris, formerly Salavin Collection
97 × 137 cm.	Honfleur, Nôtre-Dame-de-Grace
105 × 139 cm.	Orleans, Musée de Beaux-Arts
82 × 115 cm.	Evreux, Musée des Beaux-Arts
109 × 131.5 cm.	Rouen, Musée des Beaux-Arts
104.7 × 139.4 cm.	Kansas City, Nelson Gallery
109 × 123 cm.	Detroit, Institute of Arts

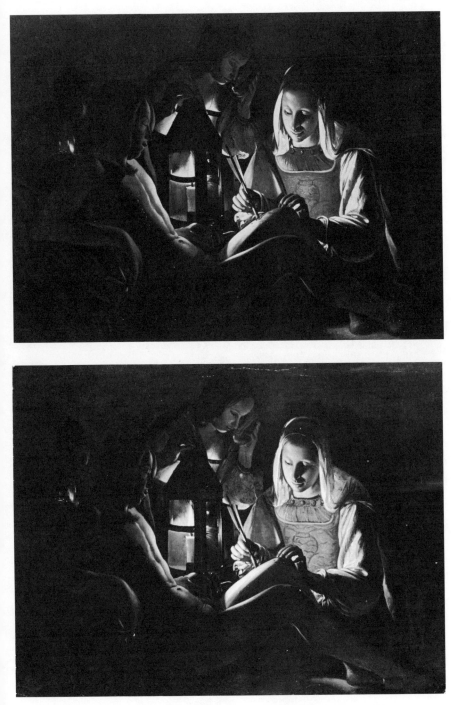

THE HURDY-GURDY MASTER

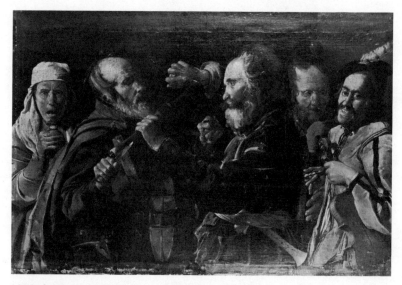

1928 *The Beggars' Brawl*. 94.5 × 141.2 cm. J. Paul Getty Museum, Malibu, California. A copy is at the Musée Benoît-Molin, Chambéry, known since the 1830s, attributed to La Tour by Sterling, 1934.

Page 45: left to right, top to bottom

1698 (in Albi Cathedral) *St James the Less*. First attributed to La Tour in the late 1940s. 66 × 54 cm. Musée Toulouse-Lautrec, Albi.

1698 (in Albi Cathedral) *St Jude*. 'La Tour' in the late 1940s. 63 × 52 cm. Musée Toulouse-Lautrec, Albi.

1791 *The Hurdy-Gurdy Player*. 'La Tour' in the 1930s. 186 × 120 cm. Musée Municipal, Bergues.

1799 *St Jerome*. 'La Tour' in the 1930s. 157 × 100 cm. Musée de Peinture et de Sculpture, Grenoble.

Page 46: left to right, top to bottom.

1810 *The Hurdy-Gurdy Player*. 'La Tour' in 1934. The key picture and the best in the whole group. 162 × 105 cm. Musée des Beaux-Arts, Nantes.

1830 *The Hurdy-Gurdy Player*. 'La Tour' in the 1930s. 157 × 94 cm. Musée Charles Friry, Remiremont, Vosges.

1920s *St Jerome*. 'La Tour' in the 1930s. 153 × 106 cm. Nationalmuseum, Stockholm.

1942 *St Philip*; from the same series as the two pictures at Albi; 'La Tour' in the 1940s. 63 × 52 cm. Chrysler Museum, Norfolk, Virginia.

[*not illustrated*: 1973 *The Bean-eaters* 74 × 87 cm. Staatliche Gemäldegalerie, Berlin-Dahlem. Discovered and attributed to La Tour, 1973].

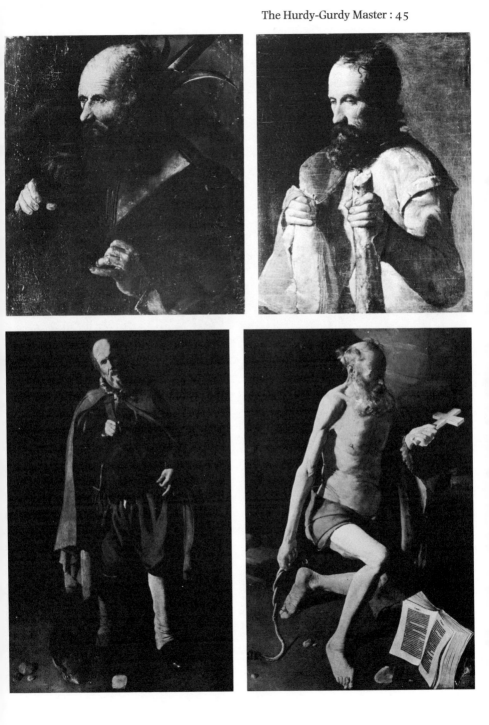

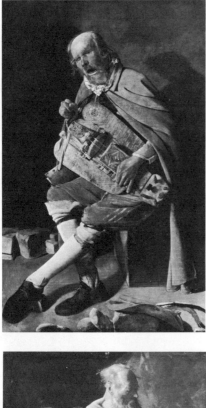

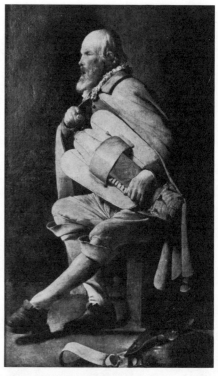

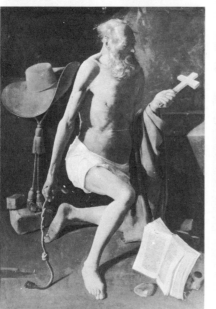

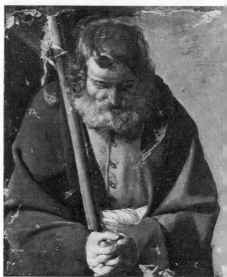

CHAPTER 1

The Metropolitan Museum, New York, buys for an undisclosed but large sum believed to be close to three quarters of a million dollars, a hitherto unknown 'masterpiece' by that rarest of French seventeenth-century painters, Georges de La Tour.

THOSE WHO KNOW AMERICA well will realise the full extent of the prestige of the Metropolitan Museum of Art in New York. It is undeniably one of the great museums of the Western world, having numerous departments covering most aspects of man's activity in both the fine and the applied arts. Lacking the immense concentrations on specific areas found in Paris, Leningrad or London, it is one of the world's most comprehensive museums. Most of its departments boast works of international importance and right through the present century it has been the museum's ambition to improve in each and every area by the acquisition of prestigious works of art. It would be unusual, given the museum's ambitions, if forgeries had been entirely avoided. Indeed in a number of cases museums such as the Metropolitan are the unwilling recipients of forgeries from over-enthusiastic donors. Yet the Met (as it is popularly called) has had more than its fair share of forgery scandals, many of them long in the past, precisely because it has been so ambitiously acquisitive over such a broad area.

Most of the forgery problems of the past have arisen in the notoriously difficult area of Italian Renaissance bronzes or the even more frequently forged area of Etruscan art. For old master paintings there has been remarkably little questionable material with which the museum has been involved. One of the reasons for this has been the fact that a large number of the museum's best pictures have come from the donations and bequests of a few distinguished private collectors who had often worked with the best advice then available. The purchase of pictures on the open market has, compared to some American museums, been relatively few. Most of these, as would be

expected, have been prestigious on an international scale. Three times in recent years, indeed, the Met has created a sensation by paying a world record price, for pictures by Rembrandt, Velasquez and Monet. It is therefore ever more likely that one of these prestigious acquisitions may well turn out to be wrong on some count just because so much is at stake.

In an ideal world an important purchase simply enhances the quality of a particular museum's collection; in practice a large number of other factors come into play. Foremost is often the reputation of the particular director or curator involved and the Metropolitan Museum has had a spectacular instance of this in the person of Thomas P. Hoving, its former director, who has written a book covering his controversial years at the museum.

The other factor is the vast amount of money involved. If, for instance, a mistake is ever made, then a very large amount of cash may well have been lost, with the result that many people have a vested interest in defending the particular purchase. A particularly sad event was the much publicised case of the 'Raphael' bought by the Boston Museum of Fine Arts. When the museum lost the picture on legal grounds because it had been smuggled from Italy it proved impossible to retrieve the money from the person to whom it had been paid. Thus the museum lost both the money and the picture.

When the Metropolitan Museum announced the purchase of La Tour's *Fortune Teller* from the distinguished French dealer, Georges Wildenstein, in 1960, it at once became a world-wide sensation (orchestrated by the museum's ever-active publicity department). Here was a spectacular picture by a then little-known French artist purchased by the museum for a very large sum of money. The facts about the picture as they were then presented astonish by their simplicity. The museum announced the picture by exhibiting it. No statement was made as to where it had come from. A year later a learned article was published on it in the *Bulletin of the Metropolitan Museum*, which remained silent about the picture's history.

The French Press mounted a campaign against the art-establishment in Paris, because it was felt that such a national treasure should not have been allowed to leave the country. No mention was made of the fact that the picture had never been

seen in public in France; (indeed, the evidence of its very existence in France had to be reconstructed from information which came to light much later).

One of the main protagonists was André Malraux, the then minister of culture, who seems to have been at the head of the campaign of outrage against the loss of such a potentially important work in the history of French culture. Malraux's anger was directed at a most unexpected source – the curatorial staff of the Louvre. This was because it emerged that no less a person than the head of the Old Master Paintings Department of the Museum, Germain Bazin, had been responsible for signing the export licence for the picture. M. Bazin was in effect removed from his post by Malraux's pressure over the La Tour matter. To this day M. Bazin has remained silent on his precise role.

Inevitably there has been much speculation as to why M. Bazin felt able to sign the crucial export paper without making the whole affair public. M. Bazin's own writings about seventeenth-century European painting have an undoubted air of authority, and it seems too far-fetched to suppose that he signed the licence paper either carelessly or under financial or other pressure from Georges Wildenstein (the reasons usually provided by art world gossip).

What is the most likely explanation is that Bazin did not consider the picture, an unusual object to say the least, to be of sufficient importance, and signed the export licence without giving the matter any further thought. After all, in the context of the time, such pictures attributed to La Tour could still be taken as curiosities rather than works of real artistic significance.

The critical matter of where the picture had been in the years immediately before 1960 was still not clear, but a certain M. René Huyghe wrote to the French Press saying that he had seen the picture as early as 1948, when he had been on the Louvre staff. He added that at the time the Louvre had declined to purchase the picture because there were not enough funds to meet the (still anonymous) owner's asking price.

The French Press in the end came to the conclusion that the whole affair was one of shame and humiliation for the French cultural scene. France had 'lost' a masterpiece and the

Americans could pride themselves on a new star on their cultural horizon.

The negotiations which led up to the Met's purchase of *The Fortune Teller* have never been recorded in print. The deliberations of the committee which sanctioned the purchase of the picture have never been made public. It is likely that the then curator of old master paintings, the late Theodore Rousseau, had an influential hand in the purchase. As both he and Georges Wildenstein (who sold it) are dead, there can be no further enquiry.

It appears, interestingly, that the picture was offered at the same time to the National Gallery of Art in Washington, who turned it down on grounds of its lack of artistic quality. This information came from John Walker, former director of the gallery. According to Mr Walker it never entered his head that the picture might be a forgery but he did not feel it to be a suitable companion to the Poussins and Claudes already in the Gallery.

The scholar who wrote about the picture in the *Bulletin of the Metropolitan Museum* was the late François-Georges Pariset, Professor of the History of Art at the University of Bordeaux in France and doyen of La Tour studies, having published the standard monograph on the artist in 1948. Pariset had an established reputation of great distinction as a scholar and only as a result of my own work in the archives of Lorraine were some of his conclusions found to be false.

Pariset's article was well written, as was usual in his work, with a good sense of story. The picture was compared with a then almost equally unknown work attributed to La Tour, *The Cheat*. This picture had been in the collection of the former French tennis champion, Pierre Landry, since at least 1932. It had been exhibited several times in the 1930s in England, France and America, and consequently became well known. It was not seen in public again in Europe until the La Tour exhibition held at the Orangerie in Paris in 1972.

Apart from the then invisible *Cheat* Pariset had, therefore, relatively little with which to compare *The Fortune Teller*, as it manifestly did not relate to La Tour's masterpieces of candle-light painting. He had as a consequence to concentrate on its qualities as a picture in isolation.

Significantly for later developments, Pariset examined the bizarre nature of the costumes in the picture, describing them as of Persian, Sassanid or Balkan origin. Such an idea, presumably written as an attempt to explain the oddness of the dress, would be very difficult to accept from a seventeenth-century Lorraine artist. Pariset's comment, which now seems impossibly wrong, was to be the starting point for a whole campaign against the illogicality of the costumes.

Re-reading Pariset's article now, with hindsight, it astonishes by its trusting naïveté and its powers of imaginative invention. As if writing for a Sunday School, Pariset was unable to come to terms with what is surely the real nature of the subject – that of a procuress. Yet since his article, no scholarly writer, and certainly not the Metropolitan Museum, has considered it necessary to change the identification from *The Fortune Teller*, the museum's odd choice of title.

Once the protests of the French Press had died down the picture entered almost a decade of 'security' when it remained unchallenged on the walls of the museum. In order to assess the full significance of this, it is necessary to turn the clock back almost twenty-five years, a period in which there have been enormous changes in the way art expertise has been practised.

In 1960 it was still largely accepted that it was possible for an individual scholar to be right on an enormous range of subjects, basing his judgment on intuition and experience alone. Today the position is exactly reversed. What has happened is that scientific analysis and a so-called 'scientific' approach to history have largely removed the credibility of intuition when studying works of art. The result of this is that some scientists have become all-powerful and now make pronouncements on the attribution of pictures.

At this stage *The Fortune Teller* stood in official terms as a masterpiece. Yet a search of the art literature of the time is extremely significant. The picture was too newly discovered and too different from accepted works to have had itself written into the main art textbooks of the 1960s. At a later date I made a very careful search for mentions of *The Fortune Teller* in art literature before 1960.

I found not a single specific mention of *The Fortune Teller* by name, but three oblique references, all by scholars who had

some role to play in the later defence of the picture as being authentic.

The first reference came as early as 1950 and was made by the eminent connoisseur and writer, Vitale Bloch (my own admiration for him was so great that I dedicated my own short book on Vermeer of Delft to his memory). He had written the introduction to a small album of La Tour's pictures which appeared both in Dutch and Italian (Bloch wrote with great facility in most European languages). In a footnote he mentioned that he had been shown a photograph of an important early La Tour although, he added, the owner did not at the time wish to make it publicly known. This reference has usually been presumed to be to *The Fortune Teller*. Unfortunately in the years that I knew him, Vitale, as he was known to his friends (Fatale to his enemies!), remained silent on the matter of how he had first known about *The Fortune Teller*.

Less cryptic than Bloch's was the mention the following year by the equally distinguished Charles Sterling, again obliquely, that he had seen an important early La Tour, once more with the requirement that it was not to be made public. Neither Sterling nor Bloch mentioned that *The Fortune Teller* was 'signed'. Sterling's testimony is especially important. He had played a decisive role in the rehabilitation of La Tour in the 1930s culminating in his organisation of the 1934 exhibition in Paris devoted to French seventeenth-century painting, when no less than twelve pictures attributed to La Tour were included.

Charles Sterling is at the time of writing still alive and neither he nor Bloch, before he died in 1976, challenged the suggestion that their remarks of 1950/51 referred to *The Fortune Teller*.

The third hint was from the mid-1950s when Professor Pariset produced the tantalising statement that it would be a splendid thing if the Historical Museum of Nancy could acquire an early La Tour signed 'Lunéville Lorraine'. Are we to attribute clairvoyance to the late Professor Pariset, or did he know *The Fortune Teller*?

To the non-specialist these comments seem no worse than professorial vagueness. Yet in terms of the way art historians work it is most unusual: what normally happens is the reverse. Scholars normally try to publish details of discoveries before

rivals can get into print. My interpretation of the evidence is that neither Sterling, Bloch nor Pariset were confident enough to make a direct statement about the attribution.

Of the important figures involved in La Tour studies, three have thus featured in the preliminary references to *The Fortune Teller*: Pariset, Bloch and Sterling. All three were on the organising committee of the Orangerie exhibition of 1972. The other people involved at this stage were far less obvious and not so much in the public eye. The art dealer Georges Wildenstein himself was both a formidable scholar and connoisseur, as his extensive books on a wide variety of subjects in French art show. He died in 1963, too early to have played a part in the subsequent battle. There was no other La Tour scholar active in the 1960s with the exception of Anthony Blunt, then Surveyor of The Queen's pictures and Director of the Courtauld Institute of Art. With Charles Sterling in 1960 he organised the Nicolas Poussin exhibition held in the Louvre and in 1967 his monumental three-volume book on Poussin appeared, acting as the climax of his long and distinguished career.

When Blunt is criticised in the context of this story it must be noted that at the time of his greatest success he and his reputation were virtually impregnable.

Blunt never publicly took notice of the changing assessment of La Tour at this time but behind the scenes he was certainly active. In 1947 he had written a cleverly argued but entirely fallacious article in *The Burlington Magazine* on a controversial picture in the Musée des Beaux-Arts at Nantes, *The Hurdy-Gurdy Player*. The painting had been in the museum since 1810 and at the time of the 1934 exhibition in Paris Sterling had insisted that it was by Georges de La Tour, although (unlike his work) it was a daylight scene. The attribution to La Tour of this cruelly realistic picture of a beggar with a bluebottle resting on him did not gain general acceptance. Several voices of protest were raised at the time – including those of the mayor and museum director at Nantes.

Blunt's article concentrating on the relationship of *The Hurdy-Gurdy Player* to M. Landry's *Cheat* seemed to clinch the matter. With this provocative article Blunt was established as a major connoisseur of La Tour. Curiously enough in the same year he organised at the Royal Academy an exhibition of The

King's pictures in which he was not able to recognise fully the perfectly authentic La Tour in the Royal Collection, the *St Jerome* at Hampton Court. We may well ask was Blunt's hesitancy based on scholarly caution? He had been bold enough with *The Hurdy-Gurdy Player*. Or was it based on a deliberate attempt to diminish the idea of La Tour being exclusively a candle-light painter? The latter conclusion is strengthened by the words of Blunt himself, as recently as November 1982, when he wrote in *The Burlington Magazine* that his (he used the word 'our') view of La Tour has not been essentially changed since the appearance of M. Landry's *Cheat* in 1932.

During the 1960s Blunt never made any comment about *The Fortune Teller*, and his subsequent behaviour suggests that as well as supporting it wholeheartedly he was prepared to defend it as being a masterpiece.

The late 1950s and 1960s were in fact a black period for La Tour's reputation, because this was the time when the number of pictures attributed to him grew alarmingly. Sterling it will be remembered accepted twelve, including M. Landry's *Cheat* and the controversial *Hurdy-Gurdy Player*. M. Pariset's book in 1948 had presented a truly spectacular increase to about forty pictures, even though reviewers at the time (including Blunt) challenged some of his attributions. Pariset's book was the signal for further new discoveries and attributions to La Tour of already known pictures.

One of the main discoveries of these years was another questionable picture, the penitent *Magdalen*, now also in the Metropolitan Museum. It is unacceptable as a La Tour and its defects will be studied in detail in a later chapter. Like *The Fortune Teller*, *The Magdalen* was first published by Pariset, this time in the prestigious *Bulletin de La Société de l'Histoire de l'art français*.

Blunt had reached the pinnacle of his career in the 1960s. He was surrounded by an admiring circle of students in the Courtauld Institute whom he encouraged, often showing great effort in helping them. The accolade of Blunt was a passport to a good career in the museum or university world and there are many who still carry that passport. Blunt was immensely busy on a variety of fronts. He was careful to vet, through his special

relationship with the then editor of *The Burlington Magazine*, the late Benedict Nicolson, all the material in his field of seventeenth-century studies which was published there. I once asked Benedict Nicolson why he deferred to Blunt so much on editorial matters and he replied somewhat sheepishly that 'Anthony has been a member of the editorial consultative committee for a very long time'. He remained on that committee until his death in March 1983.

The importance of the Courtauld Institute in this period cannot be overestimated, because the better American universities, while producing distinguished students, paid little or no attention to the art of connoisseurship. Thus when the authenticity of pictures was at stake, it was to Europe, and especially to England, that American museums came.

It was into this rigid institution that I came in 1967 as a graduate student from the University of Leeds. I was to study for two years at the Courtauld for the degree of M.A., specialising in seventeenth-century painting. This ended up in fact in my concentrating on the art of Nicolas Poussin because of the presence of Blunt and the recent publication of his book. During the second year of the course – the academic year 1968–69 – one of the requirements was some original research. I chose Georges de La Tour for the obvious reason that he was, in my opinion, a painter who combined the essential ingredients for exciting research – pictures that were moving, and considerable obscurity.

The evidence which forced me to the conclusion that *The Fortune Teller* in the Metropolitan Museum was not genuine came to me during the process of that research. The acceptance and rejection of that evidence centred on my relationship with two people. The first was Blunt, who was supervising my studies. The second was the late Benedict Nicolson, with whom I was to have an interesting and lasting friendship. At the beginning of my studies I did not set out to challenge anything, only to find out new information. I had already learned the lesson of caution during my first degree when it became clear to me that an enquiring mind was highly thought of as long as one did not upset the established premises (and prejudices) of one's discipline.

CHAPTER 2

The author challenges the authenticity of The Fortune Teller *and is silenced by the opposition of Anthony Blunt and others.*

THE PROCESSES BY WHICH an art expert arrives at his conclusions are usually a well-guarded secret. In the pioneering days of the subject, the great Bernard Berenson was especially secretive about how he arrived at his portentous 'Yes' or 'No'. Today there is great emphasis on scientific analysis, and art historians describe themselves as having 'scientific' methods, without ever providing a detailed explanation of how they work.

In the case of Georges de La Tour the general problem of defining his work is much simpler than it might first appear, since there is not a great weight of literature and opinion from the previous three centuries, because La Tour was apparently forgotten immediately after his death. All that exists for sifting is the fragmentary documentation, the surviving pictures, and twentieth-century opinions of them. This lack of material is dramatically different from the case of Rembrandt, for example, where it is of paramount importance for the connoisseur to take note of the observations of his predecessors over the last three centuries.

It was this task of collecting all the available information that I set myself for the second year of the M.A. course at the Courtauld during the academic year 1968–69. The Institute at that time could be described as a benevolent despotism under Anthony Blunt. One of his most important characteristics as a teacher was his power to encourage students to go off on their own to discover new information about the artists they were studying. For forty years he had been sifting and adding to his own the views of his many students, some of whom pursued brilliant careers on their own later.

At this time it is no exaggeration to say that Blunt was at the height of his powers. His encouragement of my research was

enthusiastic and he was very happy to send me off to Lorraine in the East of France to study the surviving documentation concerning La Tour. It was believed at the time that all the documents had been published by Professor Pariset, even though Blunt himself had often disagreed with Pariset's conclusions.

The old duchy of Lorraine, in spite of three destructive wars in the last hundred years, had kept an enormous number of documents from the seventeenth century, chiefly in the archives at Nancy, Metz and Lunéville. My objective was to check each document as published by Pariset against the original. This yielded several surprising results. The first was the inexplicable discovery that Pariset had misquoted some of the documents, muddling them up on occasion, and had even made tantalising mentions of documents no longer to be found in the Lunéville archives. I was not able to draw any conclusion from my findings but I became suspicious that something had been hidden by Pariset. What had in fact been hidden was something much more interesting. This was the incidence of La Tour's signatures on a number of documents. He acted as a witness to property transactions and appended his signature. In one case a whole document was written in his hand. (This turned out to be one of those muddled up by Pariset.)

Finding La Tour's signatures on the documents stretching over a period of almost thirty years led me to try to compare them with the signatures on the paintings. One of the problems which had bedevilled all writing on La Tour until that time was the concept of the artist's 'chronology'. Scholars normally try to date pictures so that they can chart the progression of the painter's genius. Inevitably in the hands of some unimaginative academics, 'dating' becomes an end in itself, a kind of erudite game.

My own method with the La Tour signatures was to place the document signatures in chronological order and then to place the signatures on the pictures against them, matching them. This proved to be a difficult task as each owner of a La Tour had to be contacted and requests made for photographs of the signature. This method was encouraged by Blunt who thought that it was a perfectly legitimate way of attempting to solve the problem.

1620 *Georges de la Tour*

George de la Tour 1638

1628 *La Tour*

La Tour 1642

1631 *que La Tour*

La Tour 1643

1631 *fils George de la Tour*

La Tour 1645

1631 *La Tour*

La Tour 1645

1631 *La Tour*

La Tour 1646

1633 *George de la Tour*

La Tour 1646

1634 *George de la Tour*

La Tour 1648

(above) The Louvre *Magdalen*
(right) *The Dream of Joseph*

(above) *The Dice Players*
(right) *The Denial of Peter*

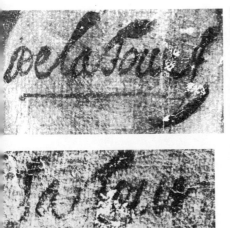

(above) *Boy Blowing on a Charcoal Stick*
(above left) *The Education of the Virgin*
(left) *The Smoker*
(below left) *The Girl with the Brazier*

QUESTIONABLE SIGNATURES: (below) *The Fortune Teller*

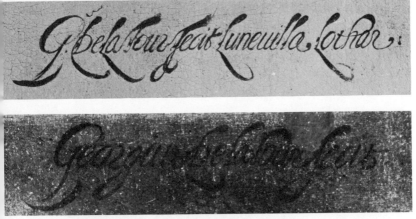

(above) The Louvre *Cheat*
(left) Brussels *Hurdy-Gurdy Player*.
This canvas has revealed another
composition underneath the picture,
and may be dismissed as a crude
and probably recent imitation.

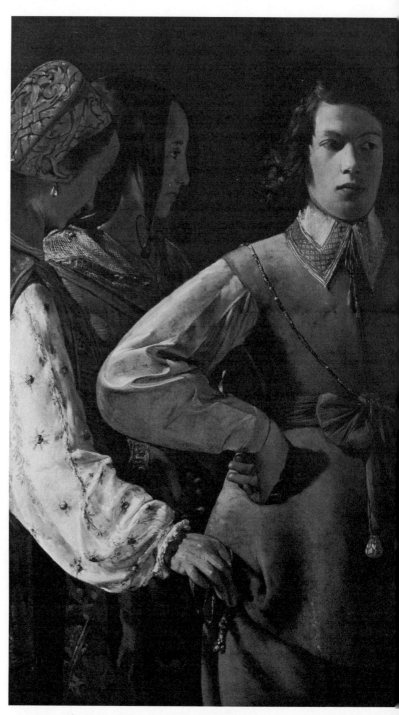

The Fortune Teller. Signed upper right: G. de La Tour Fecit Luneuilla Lothar.

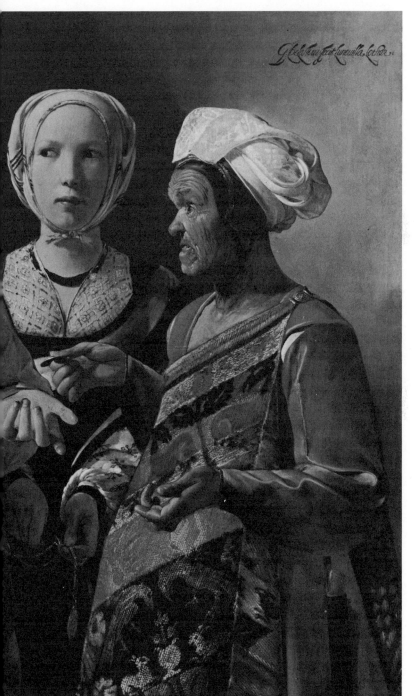

102 × 123.5 cm. Metropolitan Museum, New York.

When all the photographs and document photocopies were finally put together it allowed a number of positive conclusions. The easy one was that the well-known 'Georges de La Tour', *The Education of the Virgin* in the Frick Collection, bore the signature not of Georges but of Etienne de La Tour, the son of Georges de La Tour. This was in some respects no great surprise because not every authority was happy about the attribution of the Frick picture. Blunt remained encouraging and it was through his intervention that I was able to publish my discovery on Etienne de La Tour in the May 1969 issue of *The Burlington Magazine*.

Conflict arose, however, over the 'signature' in the upper right hand corner of *The Fortune Teller*. It reads 'G. de La Tour Fecit Luneuilla Lothar', and is visible from many feet away. It bore no resemblance to any other La Tour signature on a picture and no resemblance to any signature on a document. The picture had been assumed to be from very early in La Tour's career because it was so different from his mature art. I had, however, just discovered the document proving that La Tour had arrived in Lunéville in 1620. If authentic, the picture therefore had to date from that year or later. Blunt was nonplussed by my discovery and the matter would have been passed over had it not been for the work of Diana de Marly in the newly-established history of dress department in the Courtauld.

The department was founded by Stella Mary Newton in 1965 to train postgraduates in picture dating. I approached the department in 1969, and each student prepared a short report on one specific aspect of *The Fortune Teller*. They came to the conclusion that from the point of view of the costumes the picture could not have been produced in the seventeenth century. This did not please Blunt at all. Then Diana de Marly, the specialist in seventeenth-century costume, and now author of several well-received books on the subject, made a much more exhaustive study of the picture. Her conclusions were at the same time surprising and convincing.

Historians of costume work from pictures as part of their more comprehensive study as, of course, they have actual dresses which have survived. The whole premise of the study is that painters in the seventeenth century, and in other epochs too, recorded reasonably accurately the dress of their times.

When artists were required to place their figures in 'fancy' or 'historical' dress it can be proved that they used the models of their own times. In other words from the point of view of dress, or in broader terms, style, it is almost impossible for a painting to escape the fashion of the time in which it was painted. This is clearly shown in modern times with period or 'costume' films. It only takes a few years before a film made in 1960 but set in 1860 begins to look more like 1960 than a century earlier, since however hard one tries, one cannot place oneself back in time.

Diana de Marly's observations on *The Fortune Teller* were, however, of a very much more precise nature than a general feeling that the picture was not seventeenth-century. In one especially important part of the picture she was able to pinpoint the actual source the painter had used.

One of the most spectacular parts of *The Fortune Teller* is the old crone in profile on the right dressed, it appears, in some approximation of gypsy dress. She wears an elaborately woven 'shawl' which is draped from the shoulder and held by a clasp. In fact Diana de Marly showed that this shawl was taken from a carpet which appears in the foreground of a *Virgin and Child* attributed to the early sixteenth-century Netherlandish painter Joos van Cleve (now in the Walker Art Gallery, Liverpool). The

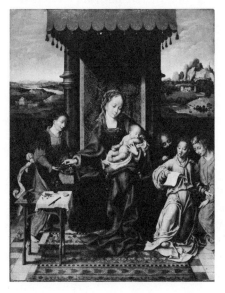

Joos van Cleve,
The Virgin and Child.
85.5 × 65.5 cm.
Walker Art Gallery,
Liverpool.

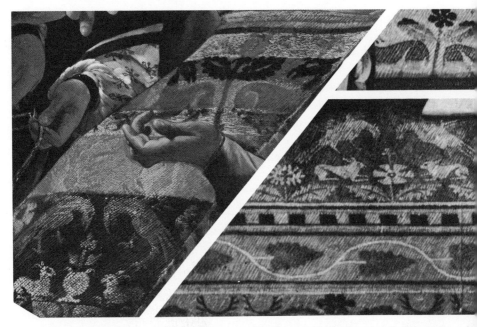

Detail: garment of the old crone in *The Fortune Teller*. Metropolitan Museum, New York. Compare the motifs with the following.

Details: carpet in the foreground of *The Virgin and Child*, attributed to Joos van Cleve.

damning piece of evidence in this respect was the fact that the carpet in the Joos van Cleve was obscured in part by the shadow of a little table falling across it. When the carpet was turned into the shawl in *The Fortune Teller* the forger had to fudge the bits of design he could not see clearly in his source.

As if the misunderstanding of the pattern were not enough, Diana de Marly was also able to point out that the warp and the weft of the textile were misunderstood in *The Fortune Teller*, and were not running at right angles. It has been suggested that it is perfectly possible for La Tour to have *invented* the 'shawl' from the material available to him. This argument falls down because throughout La Tour's authentic pictures his costumes are accurately observed.

Diana de Marly's findings in other areas of the picture were equally devastating. She noted that the young cavalier in the centre of the picture was wearing a military leather buff coat. There are several surviving examples of this type of garment made of leather. They are at least a quarter of an inch thick for protection, fastened by an elaborate system down the front. In

The Fortune Teller there has been no attempt at realism: just a flimsy garment without any visible means of fastening. Her comment that the 'leather' looks as if it were held together by a zipper has produced outrage amongst certain other costume experts. They point to the seam down the front of the woman's dress in the central figure of La Tour's *New-Born* at Rennes without realising that male and female costumes were different. The confusion here is that ordinary textiles were stitched. Men's leather doublets on the other hand could not be made in the same way. Without a front opening the tightly fitting leather coat could not be put on.

(left) Detail: cavalier's buff coat in *The Fortune Teller*.

(right) Two seventeenth-century military buff coats. Museum of London.
Note the fastening necessary in waisted garments of leather.

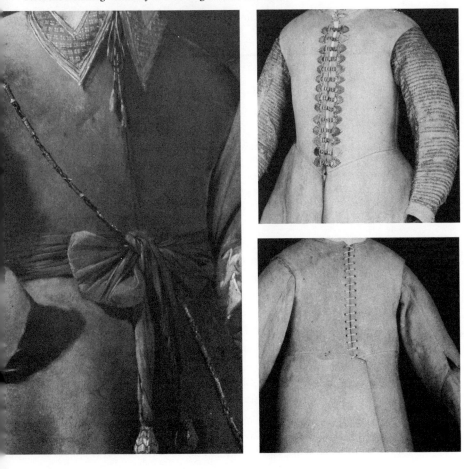

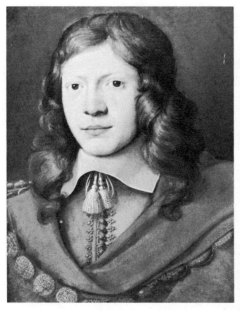

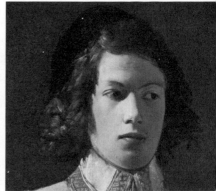

Detail: head of the cavalier in *The Fortune Teller*.

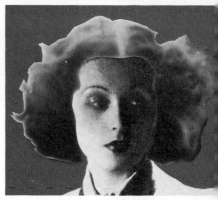

(above) *Head of a Young Man.*
39.4 × 30.5 cm.
Beecroft Art Gallery, Southend-on-Sea.
A recently discovered portrait of a young
cavalier, which shows buff-coat
fastenings. The long hair falls naturally,
unlike the permed hair of *The Fortune
Teller*'s cavalier.

The face from a *Vogue* fashion photograph of 1946 by Norman Parkinson, with a
hairstyle superimposed from a photograph of the author's mother holidaying in
Skegness in the late 1940s.

The weakness of the cavalier figure does not end there. Diana
de Marly pointed out that the cavalier's sash was in the wrong
place as it would have been impossible for him to have drawn
his sword if it were fastened down the front. The gold chain he is
wearing, being cut by the secateurs, would have hung down to
an absurd position below the knee. The man's decorated collar
with its sharp points is unthinkable for the first half of the
seventeenth century. The head shows a perfectly made-up face
with plucked eyebrows, bearing exactly the same features as
the prostitute immediately to the right. The model for the two
figures was surely the same. The cavalier's hair defies the law of
gravity and sticks out at an angle of forty-five degrees, exactly
as if some stiffening agent had been used. The beret itself, at a

rakish angle, completes this young stylist who looks at us so disarmingly.

Those who enjoy old movies will see that the young cavalier has some characteristics of women's fashion in the 1940s. There is the elegant high forehead, careful make-up with emphasis on the redness of the lips, and permed hair with the beret at a rakish angle.

The two figures on the extreme left of the picture were merely clumsy and badly drawn. Their costumes corresponded to no particular epoch, and the hairstyle of the second figure from the left was especially poor and reminiscent of the nineteenth century.

At the time of this research I did not know Diana de Marly well but we were brought together by my being present at her first seminar on the picture, and by our subsequent discussions. We came to the joint conclusion that *The Fortune Teller* must be a forgery. Immediately, the trouble began: unexpectedly, Blunt began to say that we were both wrong. Blunt opposed Diana de Marly on the grounds that her new-fangled discipline did not have the authority to authenticate or dismiss pictures. He wrote to her, stating that as in his opinion *The Fortune Teller* was by La Tour there must be some other explanation for Diana de Marly's conclusions. Thus the costume study was dismissed by Blunt as irrelevant.

At this point, Blunt and I had not discussed the picture stylistically, but I pointed out to Blunt something extraordinary: woven into the shawl of the second figure from the left was the inscription 'MERDE', the French word meaning 'shit'. It was written in capital letters of the modern type rather like graffiti in a public lavatory and certainly not in seventeenth-century calligraphy. It did not even have the floweryness of the 'signature'. Like Nelson, Blunt refused to see the inscription. I then saw him in all his vulnerability: the

Detail: MERDE on the young woman's collar in *The Fortune Teller*. Blunt and others refused to admit that it was there.

grand man in one of the most powerful positions in the art world, refusing to see what was before him, and then turning on the student who had dared to point out the obvious.

From then and throughout the 1970s I continually complained about its existence, to no avail. Then in complete vindication of my apparently untenable position, the Metropolitan Museum cleaned it off in 1982. At the same time the restorer stated that the MERDE had been put there recently. Yet a BBC television programme had just claimed for the picture the most respectable history from the famous dealer Georges Wildenstein back to a distinguished French family. Thus John Brealey, the chief restorer at the Metropolitan Museum, accused (by implication) some very important and responsible people of a hoax by exonerating the Museum, which had not previously cleaned or restored the painting.

At this point another voice entered the debate. My meeting with Benedict Nicolson had come about through the agency of Blunt, who had sent me to see him over the Etienne de La Tour signature problem. Our initial meeting had resulted in the publication of my findings in *The Burlington Magazine*, which Nicolson edited from 1947 until his death in 1978. I had then followed this article with a revision of the known La Tour documents for the early part of his career. Having completed my degree in the summer of 1969, I had taken up a post in the Witt Library at the Courtauld Institute, again through the good offices of Blunt.

In the autumn of 1969 it became apparent that the prestigious Phaidon Press, whose reputation at that time stood out above all other art publishers in the country, was interested in publishing the first serious monograph in English on La Tour. I was approached through Benedict Nicolson to be the co-author of this book. Ben, as I came to know him, had inherited a good number of the characteristics of his famous parents, Sir Harold Nicolson and Vita Sackville-West. His obituary in *The Times* described him as 'innocent and wily and garrulous and taciturn' which to a point was true. However, he had inherited a valuable gift: an independence of spirit which made him unimpressed by the grand in this world when it came to making decisions about pictures. He did not extend this freedom of spirit to his concept of social order and could often, almost without

realising it, express views more in common with the nineteenth century than the twentieth.

Proof of Ben's independence is provided by his long years as editor of *The Burlington Magazine*, because it was frequently outspoken against a good number of important figures and institutions in the art world. A good example of this was his exposure, in the spring of 1969, of a so-called 'La Tour' which had been bought for the then very considerable sum of £94,000 by the National Gallery of Ireland in Dublin. It had come via the Paris and London based dealer François Heim. What made the picture immediately suspicious was that it was another version of the already disputed *St Alexis* in the Musée Historique Lorrain at Nancy. The Dublin picture had been discovered in Belgium in the 1950s and Professor Pariset supported the attribution to La Tour.

When Ben wrote his attack on the *St Alexis* in *The Burlington* the Dublin authorities were appalled. A few months later in the same year there came my own article on the Frick's Etienne de La Tour in which I suggested Etienne de La Tour as a possible candidate for the Dublin picture as well. Blunt was furious at the embarrassment to his friends at the Heim Gallery and lost no time in recording his displeasure.

In spite of the growing opposition of Blunt I was gaining in confidence because of my increasingly close friendship with Ben. Diana de Marly and I therefore decided to write a joint article on *The Fortune Teller* in which our objections to it would be combined. Blunt expressed grave displeasure at the whole idea, yet we went ahead.

Ben received the article with enthusiasm and became visibly excited about the idea of a controversy in *The Burlington* (a characteristic which has tended to disappear from the magazine since his death). Ben agreed to publish the article. His enthusiasm was such that he wrote in *The Times* that he would publish the picture as a forgery in the near future. He also made a radio broadcast stating the same intention. Ben made it very clear indeed that he thought that the picture was a forgery, based on his own examination of the evidence.

Then came a shock after all the publicity. Ben suddenly changed his mind and decided that he was not going to publish the article after all. He wrote me a shameful letter to that effect.

He said that he was prepared to publish my article with Diana de Marly but if he did we would no longer be co-authors on the book, the idea being that I would have already published all my discoveries. This letter was totally out of character, and Ben could at any time have decided that our collaboration was no longer fruitful and could have ended it. The reason why this did not happen was that he was enjoying the shared excitement of the adventure, as each picture attributed to La Tour was still shrouded in mystery, and the provenance, and in some cases the actual location, was still obscure. How then could he have written such a letter? The only explanation was the interference of Blunt.

What happened was that Blunt insisted that my part of the article should not be published, though he was prepared to see Diana de Marly publish her half of it, warning that she would have to face the consequences. Diana de Marly said she was prepared to do so and her section of the article was published in *The Burlington* in June 1970. Her article caused little stir at the time, mainly because Diana de Marly's arguments were of a type which were new to the majority of professional art historians. Today the situation has changed because even the most old-fashioned art scholars have become more aware of the necessity for inter-disciplinary work.

Nobody else was present at the time when Nicolson was pressurised by Blunt; it could well have taken place over the telephone. (I was once present with Ben when this happened over another matter.) The evidence for the pressure is however clear enough because of the unexpected sequence of events. Blunt became very angry a few days after Diana de Marly's article was published because there appeared a short piece in *Private Eye*.

The article in *Private Eye* stated that a young scholar had found evidence that the celebrated *Fortune Teller* in the Metropolitan Museum in New York was a forgery, but his discovery had been suppressed by *The Burlington Magazine*, Britain's leading art journal. *Private Eye* took me by surprise as much as everyone else and my pleasure in seeing some of the truth emerge was marred by the fact that I could not work out how such a publication could have gained access to the inner sanctum of either the Courtauld Institute or *The Burlington*.

On the day the *Private Eye* article appeared Blunt flew into a biting rage. It was part of our terms of employment in the Courtauld that none of us could write to the press without specific permission. It is difficult to characterise the moment when I was summoned by Blunt; my main emotions were bewilderment and fear. Blunt accused me of writing the article. I denied it. He accused me again. I repeated my denial. Then he let me have it, bringing down on me the full force of his outrage, concluding that I *must* have written it as 'it was too well written' for the magazine's own journalists.

Significantly, Ben remained silent on the issue. He had already said what he wanted to on the BBC and in *The Times*. A week later I received a telephone call from *Private Eye* suggesting that I talk to them concerning the whole affair. I pointed out that I had already come very close to dismissal from my job over the previous article and therefore, although I had studied the whole question at length, and was aware that much remained to be said over the issue, I must remain silent because I feared the consequences inside the Courtauld.

Private Eye then revealed their surprise. They assured me that it would be perfectly in order to tell them what I knew about the affair for the reason that their information had come from Ben himself. This action on Ben's part (and Blunt's fury at it) further indicated Blunt's involvement in the affair.

Ben's reaction in the end was one of optimism. He realised that all the arguments put forward to that date existed in a vacuum. There had been no proper analysis of the picture itself in relation to La Tour's undisputed works, there had been as yet no scientific analysis, and the picture still had no history earlier than its appearance on the walls of the Met in 1960.

CHAPTER 3

Benedict Nicolson and the author undertake elaborate research on the work of Georges de La Tour and The Fortune Teller *in particular, with surprising results.*

BEN WAS THOROUGHLY OPTIMISTIC as we began our elaborate system of research together. He felt that all difficulties of whatever nature could be resolved by looking at all a particular artist's surviving work, wherever it happened to be situated. As he never worried about money, Ben's idea of research was simply a long series of journeys to see paintings *in situ* and to 'solve' the problems in front of the actual pictures. He was in an especially good mood about the whole idea as we planned it all together. Our work involved journeys all over France and of course America, where an increasing number of pictures both by and attributed to La Tour were to be found.

These long journeys together were extremely fruitful in many ways. Ben could not and would not take aeroplanes because however unlikely it may seem, he believed that they would exacerbate what he called his vertigo. The cause of this is found in the diaries of his father Sir Harold Nicolson, where it is recorded that Ben's first flight was in a plane piloted by Lindbergh, and Ben thought that aeroplanes had remained like that. This aversion had one good effect: it slowed down our travel and allowed for much longer discussions about individual problems than would normally be possible.

We were able to formulate our own independent views about each picture as we saw it, and then test these opinions against each other's point of view. This was for me one of the most illuminating experiences of my career because I was able to witness, in a manner totally denied to me by the much more secretive Blunt, the way in which a distinguished art historian worked. It made me aware of the weaknesses of Ben's methods in certain aspects of connoisseurship, though I became convinced that the methods he employed when looking at pictures were the best which were then available. Intellectually, Ben

had few pretensions. He had a sense of fun of the type which enjoyed the placing of a squib under the schoolmaster's desk. He was therefore not in the slightest bit worried about the idea that the Metropolitan Museum might contain a forged picture because he was not unduly impressed by that august institution.

During these journeys together, each one of which lasted about three weeks, we discovered many new facts about La Tour's pictures, not least about *The Fortune Teller*. It is important that these facts are recorded exactly as they came to light, since it will be seen that they were to be contradicted by a new set of 'facts' which were to emerge in 1980 and after.

Our working methods for the research were particularly detailed and we had, in the case of *The Fortune Teller*, collected all the published references about the picture (by Pariset, Bloch and Sterling, all three of whom we knew). We also had to do this for every other picture attributed to La Tour and therefore had a formidable dossier on each picture. In one memorable instance we were harangued for a full hour by M. André Jacquemin at Epinal in the Vosges and things reached such a pitch that Ben hid behind a pillar! At that moment M. Jacquemin revealed the then unknown whereabouts of a 'La Tour' (in the Musée Charles Friry at Remiremont also in the Vosges) which turned out to be a genuine picture by the Hurdy-Gurdy Master (see p. 44).

We would thus arrive at each museum or private collection armed with a complete familiarity with what had been said about each picture. We had several tasks to perform once in front of each picture. The most obvious (though perhaps not the most usual) was to look at it very carefully. We would then and there discuss with each other exactly what we saw. Ben was especially good at this and some of the best passages in our book are Ben's descriptions of the emotional contents of La Tour's best pictures. Ben was much less interested in looking at the museum files on each picture and he usually left this task to me while he went outside for a much-needed smoke. Sometimes nothing was revealed by this method; in other cases the files would be extremely valuable in tracing the former where-abouts of a problematic picture.

Many of these journeys provided a good deal of innocent

amusement because Ben, not in this sense the ideal travelling companion, had very little sense of time or place. He could stare through garrulous museum curators or look abjectly helpless before a tirade. At Evreux, when trying to see one of the ten copies of the horizontal *St Sebastian*, Ben looked pathetic as a virago of a curator accused us of having come on the wrong day. She then drove off in a fast car leaving us standing staring at each other on the steps of the firmly closed museum. Ben's reaction was simply to say that we would have to go back on a more convenient day.

These minor traumas brought us great experience in dealing with separate museums and we found, sometimes to our surprise, that a very large proportion of the La Tour owners were extremely co-operative with information. There was never any sense that anybody had anything to hide, although we met a Gallic sense of proprietary pride in the possession of information. Only when we had visited France several times and gained a full familiarity with La Tour's work (except for M. Landry's *Cheat*, which was unavailable), did we set off for the United States in October 1971.

Ben was positively excited about the whole idea of visiting America, and remained steadfastly confident that we should be able to work out immediately in front of *The Fortune Teller* whether or not it was authentic. He remained absolutely confident as to the efficacy of his eye and he was well aware that we were now uniquely qualified to make a decision as to authenticity in front of the picture. We had both just read everything that had been written on La Tour; I had just examined all the original documents then known; and together we had looked at every picture in France both by and attributed to La Tour.

As events turned out we were both left in a state of confusion. Ben felt that the picture could be authentic and he was able to dispel the doubts about it which he still had by saying that as all the pictures were going to be brought together in less than six months time (April 1972) there was no need for real concern. Confrontation of all the pictures would solve any lingering doubts. I remained suspicious that the picture was a forgery but felt a good deal less self-confident.

We were received most cordially by the then curator of

Western Paintings, Everett Fahy, who is now director of the Frick Collection, New York. At the time the collection of Western Painting in the Metropolitan Museum was not on view because of a reorganisation of the galleries. This meant that we were able to study at length our chosen picture without the normal interference of large crowds and noisy lecturers which are now such a common feature of great museums. There was at that stage no sense of drama in front of the picture. We were able to study it quietly and carefully and to arrive at our decisions at our leisure. We were immediately joined in our deliberations by the director of the Museum, Mr Thomas P. Hoving (now editor of *The Connoisseur*). I asked to see the Museum files on the picture and was refused permission by Mr Hoving. I reminded Mr Hoving that the purpose of our visit was to collect information on the pictures in the hope that we could persuade ourselves that it was in fact authentic. In other words neither Ben nor I were *willing* the picture to be a forgery. It would have been so much easier for all concerned if the picture had not presented any problems and it would then have relaxed the tension between Ben and myself which had remained after the affair of the suppressed article.

Logically speaking the Metropolitan Museum had no grounds for refusing access to the files: not even in the most difficult of the French provincial museums or the infinitely grand Louvre had this happened. We were then introduced to Hubert von Sonnenburg, then conservator of European Paintings and now director of the Doerner Institute in Munich. Mr von Sonnenburg was quite explicit in his observations. He told us that he had examined *The Fortune Teller* in great detail from a technical point of view and that he had found nothing which was chemically incompatible with a seventeenth-century date for the picture. He could not, on the other hand, provide any X-rays of the picture. He later wrote Ben a letter which was to have some significance. He said that in his pigment analysis he had found lead tin yellow, which was a pigment generally believed at the time (1972) to have fallen out of use at the end of the seventeenth century.

In assessing to ourselves the significance of what we had seen at the Museum we both concluded that in our present experience *The Fortune Teller* was unique. There was no other

picture to which it could be related stylistically or historically. No pictures of that type of subject had been documented in La Tour's lifetime and certainly no other picture we had seen had such a strident colour scheme and so many figures placed together in such an uneasy way.

We were however wary of concluding too much from this because we were both aware of the *existence* of two similar pictures. The better known of the two was M. Landry's *Cheat,* which had not been seen in public since 1939 except for brief exhibition in Detroit in 1941 and Pittsburgh in 1951. The other version of the same picture was still known only from the faded sepia-printed photograph in Professor Pariset's 1948 book on La Tour, although its existence had been mentioned in connection with M. Landry's picture as early as 1934. It was in the Pictet Collection in Geneva and we had managed, after a good deal of difficulty, to obtain a photograph of it.

The fact that there were these two other pictures lurking in the background, both of which bore some resemblance to *The Fortune Teller,* was of great significance. Ben was quite rightly reluctant to come to conclusions about pictures he had not seen, neither of which had at that time an earlier history than 1930. It never occurred to either of us that we might be dealing with a complicated web whereby one dubious picture might 'authenticate' another.

We continued to pursue the earlier history of *The Fortune Teller,* and concluded that as the picture had been exported from France in 1960 with so much publicity there must have been some trace left in France of the picture's former where-abouts. Gossip in Paris provided us with a clue. It appeared that a monk of the Benedictine Abbey of Solesmes in the Department of the Sarthe (between Le Mans and Angers) knew something about the early history of *The Fortune Teller.* So Ben and I journeyed to Solesmes, full of curiosity. The monk turned out to be elderly, and received us with old-fashioned French politeness (and holy water) which disarmed us both totally.

Dom de Laborde spoke eloquently about his role in the identification of *The Fortune Teller.* The monk's story was bizarre.

It appeared that Dom de Laborde, in his long years at Solesmes, had always had a great interest in art. So, it seemed,

had other members of the Order, since there was a restoration studio in the abbey for the purpose of working on Old Master pictures, which Ben and I were shown. Dom de Laborde stated that a distinguished local family, the de Gastines, who owned two châteaux in the area (La Vagottière and La Denisière), had a remarkable art collection. In this collection was *The Fortune Teller*. No other work of art has so far surfaced with a provenance from this collection: perhaps the monk was overestimating the significance of the family treasures.

In a letter to me he elaborated on his story. According to him, a certain M. Celier, who was the nephew of Colonel de Gastines, owner of the châteaux, was taken prisoner of war by the Germans sometime in the early 1940s. Languishing in Germany he had received as part of a consolation parcel from France a small book on the art of Georges de La Tour. In this little book was a reproduction of M. Landry's *Cheat*, and M. Celier realised that back in the château of La Vagottière was a picture very similar to *The Cheat*. Immediately on his release from prison camp M. Celier returned to his family and found that the picture which he remembered had miraculously escaped the depredations of the German Occupation.

It was M. Celier who brought the picture to the notice of Dom de Laborde, who of course had a great interest in the art of the past. He was able to study the picture in some detail over a period of months at Solesmes. The date of this period at the Abbey was never specified, although by implication it was 1948. M. René Huyghe in his letter to *Le Monde* in 1960 stated that he had seen the picture in 1948, presumably at Solesmes.

What happened next had shocked Dom de Laborde. He stated that he called in M. Huyghe from the Louvre, who was impressed by the picture and wanted to buy it for the museum. At this time, immediately after the war, the museum's funds were pathetically small. According to Dom de Laborde, the famous art dealer Georges Wildenstein appeared on the scene and offered the de Gastines family a very much larger sum of money than the Louvre had been considering. Naturally, Colonel de Gastines, taking advantage of the unexpected windfall, sold out to the highest bidder. Thus the masterpiece disappeared for ever from Solesmes where Dom de Laborde had stage-managed its first launching.

Ben and I were impressed by the sincerity and simplicity of the man in Holy Orders and by the grief which he expressed at the loss to France of so important a picture. Had we now established the history of *The Fortune Teller* back to the early 1940s? Leaving aside the great good fortune of the picture's survival during the war, Dom de Laborde made one slip which arouses suspicions about the veracity of his story. In his letter confirming all the details of the de Gastines and Celier families he stated that after the late 1940s, *The Fortune Teller* remained with M. Wildenstein until 1960, when it was sold to the Met. He added that the picture had undergone a *brief sojourn* in the United States at some time during this period.

This statement was extremely surprising on several counts. How did Dom de Laborde come by this crucial piece of information when the picture was held, as we know, in total secret at Wildenstein's? It is curious that M. Huyghe himself, the only scholar to claim in writing to have seen the picture before 1960 (taking Bloch's, Sterling's and Pariset's statements as ambiguous) did not come forward in these years with any statement when he knew that so important a picture had been lost to the Louvre.

Dom de Laborde was not in fact mistaken about this 'brief sojourn' because further evidence was to emerge that the picture was indeed in the United States in the late 1950s. The monk was emphatic that from the time he first saw the picture it bore La Tour's signature in the top right hand area. He even had a few old photographs of the picture at the time it was brought to Solesmes. These puzzled me because they showed a picture more or less in the condition in which *The Fortune Teller* remained until 1981. What followed must suggest that *if Dom de Laborde's account was accurate*, the picture remembered by M. Celier and held at Solesmes might not be the one now in the Met.

The removal of *The Fortune Teller* from France in the 1950s was an illegal act. This was proved by what happened in France when the Met announced its purchase of the picture in 1960. The only evidence there is of the picture *returning* to France just before 1960 is journalist Brian Sewell's statement that he saw the picture with a Paris dealer in 1958.

The evidence for the presence of *The Fortune Teller* in New

York in the late 1950s came from the former curator of the Municipal Gallery of Modern Art in Dublin, Patrick O'Connor.

O'Connor was living in New York at this time earning a living by restoring paintings and, occasionally, dealing in them. He became friendly with a certain M. Albert Dion who, like himself, was a picture restorer and who worked for Georges Wildenstein in New York. O'Connor stated that he saw Dion working on *The Fortune Teller*. It never occurred to O'Connor that such a picture would subsequently be called a 'Georges de La Tour' on the authority of Professor Pariset.

There have been attempts to discredit O'Connor as a reliable witness but before his story is dismissed totally his statements have to be examined very carefully. I asked O'Connor why he had not been shocked by the appearance of *The Fortune Teller* on the walls of the Met, MERDE included. O'Connor's reply was that art historians were so often wrong that one more mistake seemed of little consequence: more to the point, who was Georges de La Tour anyway? At this stage Ben and I had to be content with his account. Ben was still not able to accept the presence of MERDE although he later came round to it.

What Ben never saw was on the collar of the figure just to the left of MERDE, the cypher D I O N.

CHAPTER 4

The Fortune Teller *emerges as 'triumphantly authentic' at the time of the exhibition in Paris in 1972 when all the known works by La Tour were brought together.*

BY THE BEGINNING OF 1972 Ben and I were extremely occupied in two main areas. First, we were trying to complete the draft of our joint book before the opening of the Paris exhibition of La Tour's work, which was scheduled for May. Ben was working on the text and I was putting the finishing touches to the catalogue raisonné. Second, we were on the organising committee of the exhibition, and were making frequent trips to Paris to be present at the committee meetings. At these meetings it was decided which pictures were to be lent and what was to be said about them in the catalogue. The joint authors of the catalogue were to be Pierre Rosenberg, curator at the Louvre, and Jacques Thuillier, then Professor of the History of Art at the University of Dijon (and now at the Sorbonne).

It was perhaps because it was widely known that the exhibition was about to take place that a number of new La Tour discoveries were provoked. Some of these discoveries were to be extremely important, and two entirely authentic pictures were identified, an early and a late work (although, significantly, both were treated with extreme suspicion, especially by the French authorities). These discoveries were to change our whole way of looking at the artist, though this was not so obvious at the time.

The first discovery was by Christopher Wood, then at Christie's, of La Tour's *Dice Players* in the reserves of the Teesside Museums at Middlesbrough, during a routine valuation of pictures. Ben and I had travelled to Middlesbrough to see the picture in its dirty and neglected state. It had in fact been bequeathed to Stockton-on-Tees, County Durham in 1930 but had lain neglected by the municipal authorities for just over

forty years. This was a different story indeed from the way in which *The Fortune Teller* was launched by the Metropolitan Museum in 1960.

The other discovery was even more important than the signed *Dice Players*, although it did not seem so at the time. The picture was identified in the Museum of Lvov (formerly Lemberg) in that part of the Ukraine which was formerly in Poland. It was first published in the West in the form of a short note written by Vitale Bloch in *Apollo* magazine. Ben was at first very suspicious because he could not fit the picture into the chronology he had already formulated. Ben and I had had very long discussions about La Tour's stylistic development which had at that time to include all the pictures attributed to him, including *The Fortune Teller*. After much disagreement we had to conclude that the Lvov picture, *The Payment of Dues*, was a very early work.

Our discussions were in fact in vain: after the 1972 exhibition the Russian authorities cleaned the picture, finding La Tour's signature and the date 1634. This makes nonsense of the position of *The Fortune Teller* in La Tour's development. All authorities accept the idea that the Lvov picture is one of La Tour's earliest works because of the mannerist composition, flickering lighting and a lack of the calm which pervades his later work. If the picture is in fact from the mid 1630s, when La Tour was already in his mid forties, it becomes extremely difficult to slot *The Fortune Teller* into La Tour's later development. Curiously enough this dilemma is recognised by the Metropolitan Museum in the label which the picture now bears at the time of writing. The museum authorities note that there is a dispute over the dating, indicating that some scholars place it in the early 1620s and others in the 1630s.

The exhibition of La Tour's work fascinated the general public and the reviews from all quarters were long and euphoric. The art historians concerned had many long and (to use Thuillier's word) grave discussions over the many questions which the exhibition posed rather than answered. Looking back, however, the most significant thing was the appearance of a very considerable number of 'new' pictures bearing attributions to La Tour, which were to confuse the issue in a very serious manner. These 'new' pictures fell into several

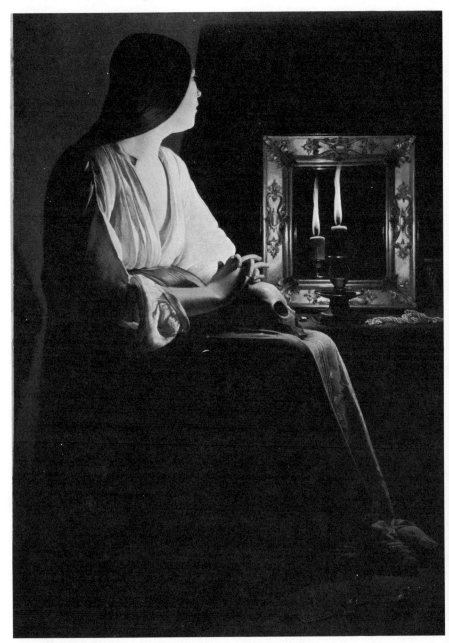

The Magdalen. 92 × 134 cm. Wrightsman gift, Metropolitan Museum, New York.

different categories. Some were of course outright old copies of known works and were easy to dismiss as such. Some were simply decent pictures by other painters, which could, given the necessary expert knowledge, be slotted into their correct places. Much more insidious were those pictures which were pretending to be by La Tour.

One of the most disturbing of these 'new' pictures was a *Magdalen*, at that time belonging to the multi-millionaires and great public benefactors Mr and Mrs Charles B. Wrightsman, who subsequently gave it, along with many prestigious pictures and other works of art, to the Metropolitan Museum. This *Magdalen* had first been identified in 1961 when it had appeared on the Paris art market with François Heim (who was responsible for the *St Alexis* being sold to Dublin in 1969). Heim had sold the picture to the Wrightsmans in 1963, presumably on the advice of Blunt, who was to become very angry when I told him that I believed that the picture was not by La Tour.

I visited the Heim gallery and discussed with them the reasons why I thought that the picture was much later in date than La Tour's lifetime. The argument I used was simple enough. There was a miserable anachronism in the picture: an elaborate Napoleonic period mirror frame in which the Magdalen's candle flame was reflected. Not only was the decoration on the frame inappropriate for La Tour's lifetime (this was informally confirmed by the Department of Wood-work in the Victoria and Albert Museum) but also the decoration was so badly observed that the arabesques went in the wrong direction.

At that time the discussion was centred on the mirror frame; as I had only seen a photograph of the picture there would be no point in discussing its other weaknesses. Heim complained to Blunt who immediately threw a tantrum. He was particularly annoyed that as an employee of the Courtauld Institute I had dared to go to a prestigious dealer and express doubt about a picture which had only recently been sold to one of the most distinguished American collectors. What was not discussed during the heated argument was what a scholar was supposed to do when he found something which might advance the cause of truth in his subject.

Ben got round the problem of the mirror frame very neatly.

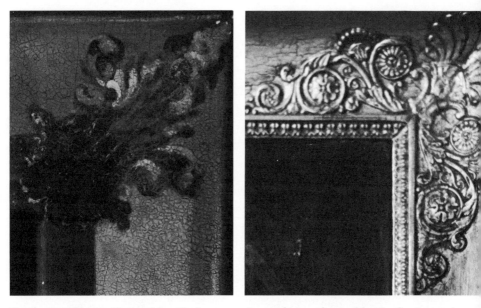

Detail: mirror frame in *The Magdalen*. The forger has not even correctly painted the reverse curves in his out-of-period frame.

A normal mirror frame of the Napoleonic period, one hundred and fifty years after La Tour. Note the symmetrical curves.

He was unimpressed both by my arguments and by the observations of the Victoria and Albert Museum. He preferred the opinion of Mr Paul Levy whose reputation was based on the fact that he was and still is one of the most skilled makers of imitation antique picture frames. Mr Levy was certain that the frame in *The Magdalen* was compatible with La Tour's lifetime and quoted a German inlaid frame of the early seventeenth century to prove his case. The German frame had appliqué decoration quite different from the supposed carvings in the La Tour, but this did not worry Ben.

The star of the Paris exhibition, and the picture which appeared both on the poster and on the cover of the catalogue was M. Landry's *Cheat*. The first time either Ben or I saw it was at the opening of the exhibition and it gave us both a considerable shock. It was incontrovertibly close in style to *The Fortune Teller*. This was agreed by all the specialists at the exhibition including myself and is still maintained by all authorities now. It was the crucial reason why all the doubters of *The Fortune Teller* were able to accept it without further ado. Here was another picture known at least since 1932 when it

was exhibited at the Royal Academy, London, which 'proved' that La Tour painted more than one picture of the type. *The Fortune Teller* was no longer in vulnerable isolation. At the opening of the exhibition the Louvre authorities announced that they had bought M. Landry's *Cheat* for the equivalent of one million pounds sterling. This made it by far the most expensive French picture ever sold up to that time.

The Cheat had at that time (1972) what was considered to be a perfectly clean bill of health. It had first been exhibited by M. Landry in London in 1932 and it had remained in his possession in the intervening forty years, exhibited only rarely and then in America where it appears to have been kept during the war years. The importance of *The Cheat* in stylistic analysis cannot be overestimated.

The initial searching analysis of the picture was first made by Charles Sterling in 1934. It is to this we must turn to find the evidence, which points to the fact that the picture cannot be by La Tour. Sterling writing his observations in good faith naturally had to compare the then newly-identified *Cheat* with the pictures which were then known to be by La Tour. This proved to be almost too easy. The serving maid bore a superficial resemblance to the wife in the Epinal *Job* and the pose of the central card player could well be reminiscent of the static quality of the Rennes *New Born*. Where Sterling created a sensation was in identifying a whole new group of pictures scattered in the museums of France as being by La Tour. The drapery of the young dupe on the right of *The Cheat* was very similiar to the treatment of the well-known but mysterious picture in the Nantes Museum, *The Hurdy-Gurdy Player*. It was this comparison which caused the attribution to La Tour of the group of pictures by the artist I call The Hurdy-Gurdy Master. Pictures by this artist (see pp. 44–6) have not been forged. They are simply the result of reattribution of existing works, long known and appreciated, to the then still obscure La Tour.

Taken in the context of 1934 nothing suspicious could be attached to Landry's picture and Sterling's interpretation of it. Only subsequent events could place the picture in jeopardy as an authentic La Tour. The most obvious fact was that *The Cheat* did not bear any striking resemblance to any authentic La Tour discovered after 1934 except one. This was the other version of

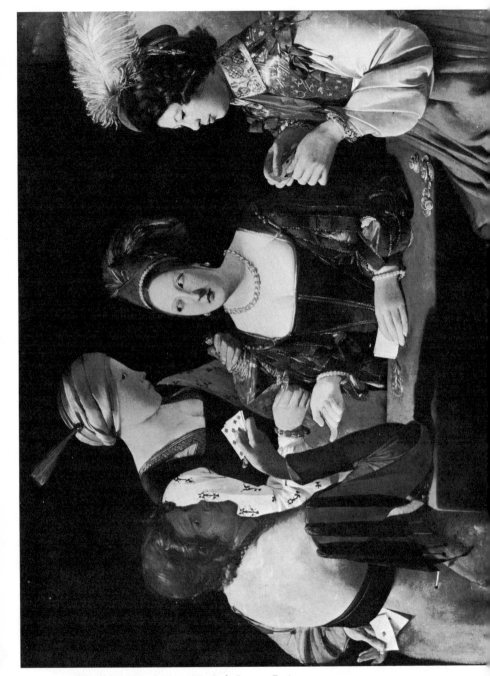

The Cheat. 106 × 146 cm. Musée du Louvre, Paris.

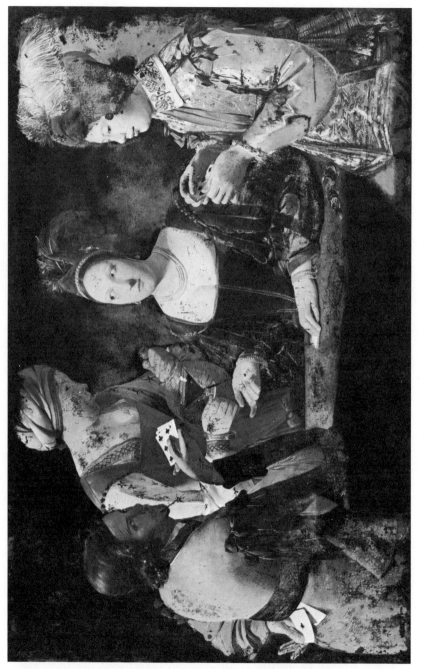

The Cheat. 104 × 154 cm. Kimbell Art Museum, Fort Worth. Reproduced (by infra-red) as it appeared when in Geneva, and before its restoration by John Brealey in 1980/81.

the same *Cheat* mentioned in Sterling's catalogue entry but not reproduced until Pariset's book of 1948.

The most dramatic revelation of the 1972 exhibition apart from M. Landry's *Cheat* was the other version of this picture, then in a Geneva private collection and now in the Kimbell Art Museum at Fort Worth. The Fort Worth *Cheat* is undeniably similar both to *The Fortune Teller* and to M. Landry's *Cheat*. The Fort Worth *Cheat* was known by 1934, as Sterling mentioned it (though without detailed discussion), and therefore if the Landry *Cheat* was in fact a 'copy' made at some time before 1932 it could be easily explained. The differences between the two *Cheats* are interesting.

All the similarities to La Tour pointed out by Sterling about the Landry *Cheat* simply do not exist in the Fort Worth *Cheat*. What affords the Fort Worth *Cheat* some defence is that the model on the left, who is concealing a card behind his back, bears a superficial resemblance to the figure, in a different pose, in the centre of the Lvov *Payment of Dues*. This picture was not known until 1972 and is undoubtedly an authentic La Tour. At the time, in 1972, of the momentous confrontation of all three pictures, the natural conclusion was that all three were by the same hand and consequently by La Tour. Only the Fort Worth picture was unsigned.

The three pictures were not placed together in the exhibition and it was necessary to dart from wall to wall to make the necessary comparisons. Not one of them had a history earlier than 1931 until M. Landry stated that he had found his *Cheat* in a private house in the Quai Bourbon in Paris in 1926. Subsequently the Geneva Private Collection was to claim (without producing the documentation) that their *Cheat* had been in the family for many generations, a claim which has to be taken seriously: such a family would have no reason to *buy* such a damaged picture in the 1920s. The three pictures presented a solid phalanx of strong lighting, brilliant colour and large scale, full of accoutrements, flashy jewellery, brilliantly embroidered textiles and sideways glances. It would have taken a great deal of imagination to suppose that all three pictures were not by the same hand and that two of them were not by La Tour. At the time this confrontation convinced me that *The Fortune Teller* must be by La Tour. The actual confrontation of

all the pictures and all the experts took place on the day after the exhibition closed. The events which led up to this confrontation brought in a number of new figures who were extremely active in their support of all the problem pictures. Messieurs Thuillier and Rosenberg, both specialists in French seventeenth-century painting, were the most articulate and the most learned members of the committee. After the exhibition closed they became the authors of separate books on La Tour. The occasion was especially interesting because all the pictures were taken down and placed in natural light along the landing of the Orangerie. We were all therefore able to look at them afresh and to have discussions with each other on the problems posed by each picture.

One of the intentions made clear at the outset was to get me to admit that *The Fortune Teller* was by La Tour. The argument was persuasive enough – the presence of the two *Cheats*. Two things stand out from this confrontation. Pariset, Thuillier, Rosenberg, Laclotte and Ben were present. There was pressure on me at the time even though I had not published a single word against *The Fortune Teller*. There was, therefore, no necessity for public recantation. If my views had not been taken seriously by this group of people they need not have gone to such trouble to persuade me to change them. Laclotte and Rosenberg had just been instrumental in the Louvre's purchase of *The Cheat*. Pariset had published all the pictures and any denunciation would inevitably reflect on his position as the expert.

The second issue was much more important. This was the extraordinary refusal by all those present (except Ben) to see MERDE. The presence of this lavatory-wall style graffiti was one of the major reasons why *The Fortune Teller* had aroused my suspicions. Why did all those present refuse to see it?

Now it has been removed those who refused to admit it was ever there do not, conveniently, need to discuss it. At the time Thuillier, always a wit, said to me 'Ah Cannossa'. Looking back it seems very curious that such a group of people should have been at such pains to make me change my mind. It is a tribute to Ben's intellectual honesty that he did not object to my inclusion of 'Merde' in the catalogue entry on *The Fortune Teller* in our book. He supposed that some perfectly rational explanation for

it would sooner or later be brought to light.

A crucial stage in the story of the launching of the forgeries had thus been reached. The credentials of *The Fortune Teller* were, it seemed, firmly established. It had stood the acid test of comparison with other pictures. It seemed not to worry anyone that *The Fortune Teller* had no connection whatever with any undoubted La Tour which was a candlelight piece. Nobody, not even Ben, was able to see the weaknesses in *The Fortune Teller* either in isolation or when compared to the genius of La Tour's best pictures.

La Tour's great ability as a painter has sometimes been difficult to justify on the grounds that he was neglected for almost three centuries. This is to misunderstand history. It was only La Tour's biographical details and the attributions of his pictures which were forgotten. The paintings themselves were esteemed enough. Charles II had a La Tour, and it has remained in the Royal Collection since his time. Almost all the pictures in the French provincial museums were noticed by guide book writers and there is every indication that the La Tours at Nantes were very highly esteemed (*The Dream of Joseph* being attributed to Rembrandt!).

In analysing La Tour's abilities as a painter one of his strongest characteristics, apart from the unique lighting, is his unerring sense of line. Many of his figures take up slightly awkward poses and twist their limbs in odd ways, as for instance the child's hand in the Nantes *Dream of Joseph*, or the curve of Joseph's back in the Louvre *Christ in the Carpenter's Shop*. Every small detail of each authentic La Tour reveals an obsession with the way limbs, drapery or faces are drawn. When we turn to *The Fortune Teller* though, its incompetence in drawing seems outstanding.

The worst part of *The Fortune Teller* is the structure of the two figures on the left. The neck of the figure on the extreme left is totally out of alignment. On the same figures the confusion of the hands was to become more apparent in the light of later discoveries (pp. 110–11). The misunderstanding of the weave of the textiles on the shawl of the old crone on the right has already been discussed. In other words, from the point of view of drawing the picture is something of a shambles, a fact which separates it from the two *Cheats*, which are much better drawn.

Detail: Figure on left in *The Fortune Teller*, with a diagram indicating the correct angle for the neck in true perspective.

Significantly, in the two years which followed the closure of the exhibition the comments which appeared about *The Fortune Teller* in the respective learned books assiduously avoided discussion of the picture's weaknesses. If the picture were indeed authentic why gloss over shortcomings? In my own experience, in writing about the evolution of great painters it is normal to analyse in detail their earliest efforts and to demonstrate by this method the course they took towards their greatest achievements. In *The Fortune Teller* its defenders will not admit to its weaknesses.

The Fortune Teller and even more the Louvre *Cheat* (the Fort Worth version went back to Geneva and remained in obscurity during the rest of the 1970s) proved useful fodder for a heresy beloved of art historians.

One of the secret ingredients of the forger Van Meegeren's success with the Dutch art-historical establishment was to introduce references to Vermeer's early relationship with Caravaggism through the Caravaggesque painters of Utrecht. In La Tour's case the debt to Caravaggio could be seen to be much more direct. Caravaggio had himself painted a *Fortune Teller* (Louvre) and a *Cheat* (last seen in the Rothschild

Collection in the 1890s). Hence the La Tour treatments of the same subject 'proved' La Tour's awareness of international trends. Such ideas are shown to be nonsense by the Lvov *Payment of Dues* because this early La Tour is everything one might expect from a painter working in the isolation of Lunéville. The stylistic references are to the fashions at the ducal court at Nancy rather than to Caravaggio's work, most of which was then inaccessible in Naples, Malta and Sicily. More of his works were visible in Rome but these did not influence La Tour.

For those who accepted *The Fortune Teller* as one of La Tour's significant achievements, proving his internationalism, the picture had just gone through the process of rehabilitation normal for newly discovered works. Most people thought then and still think that I had fought a totally unnecessary campaign against the picture, because it had been accepted by every other La Tour authority. Even now I believe that they acted in good faith. Apart from Diana de Marly's article they had not been presented with the real evidence in print against the picture. Very few of the events so far recounted in this book were publicly known. The weakness of those who wanted to defend the picture was their refusal to see the first piece of damning evidence in the form of MERDE. Nobody was in a position to doubt Dom de Laborde's story because the evidence about the picture's presence in New York in the 1950s had not been brought out. In the last three years much more information has come to light. The main parties, falling over themselves to establish the truth, have ended up in cancelling each other out.

CHAPTER 5

The author launches a second attack denouncing The Fortune Teller *as a forgery, with unforeseen results.*

WHEN THE BOOK by Ben and myself was published at the end of 1974 *The Times* received it with a headline 'silent, unearthly and sublime'. Good reviews appeared in other papers and periodicals and this was a great help to my career as an art historian. Most reviewers were impressed with Ben's flawless but very personal style of writing, and the detailed research in the book was also noted by the reviewers. In one of the few slightly tart reviews, Everett Fahy, who had become director of the Frick Collection in New York, noted that Ben had done a *volte face* over *The Fortune Teller* and accepted it as authentic. Fahy was of course referring to the fact that Ben had denounced the picture in *The Times* only five years earlier. Ben was deeply upset by certain aspects of the review and he wrote a letter of complaint to Everett Fahy, who replied and apologised for his 'flip tone'.

My name was never dragged into this aspect of the controversy as I had never been associated *in print* with any doubts over the picture. My own change of mind to acceptance of the picture in the joint book was to be one of the major sources of difficulty for me when questioned by journalists. The Press found it very difficult to understand how I could have come round to the opposite point of view and remained content to accept the praise of reviewers for attributing *The Fortune Teller* to La Tour when there was always the lingering doubt in my mind.

Ben did not live long enough to see the events which brought *The Fortune Teller* once more under attack. Ironically our book is still quoted by those who defend the picture as authentic. This was particularly obvious in 1982 when the picture was again exhibited in Paris as part of an exhibition of French seventeenth-century paintings from collections in America.

Ben died in the Spring of 1978, at the peak of his reputation. His books were few in number but they had all become standard reference works, especially those on the Dutch master Hendrick Terbrugghen and on the English painter Joseph Wright of Derby. In the address at his Memorial Service in St James's Piccadilly, the late Lord Clark paid eloquent tribute to Ben's achievements but avoided mentioning Ben's involvement with La Tour studies.

Unfortunately in the last two or three years of Ben's life our professional relationship had deteriorated. He seemed very much against the idea of my publishing further books and went so far as to oppose this actively. He never made any secret of it and was always happy to meet socially, as we always got on well together. His death was no surprise to those who knew him well as he had neglected himself for so long and smoked far too much.

At the end of 1976 I left the Courtauld Institute's Witt Library and became a full-time writer on art. There was at that time no plan in my mind to continue the La Tour battle although whenever I re-read what Ben and I had written in the first place I always found myself with an uneasy feeling about the events which had led up to our changing our minds and accepting *The Fortune Teller* as an authentic La Tour.

The event which sparked off the reopening of the La Tour question came as a surprise. I was in Los Angeles, lecturing on Georges de La Tour at the County Museum (which had just acquired *The Magdalen*, another and equally beautiful version of the one in the Louvre). I found myself staying with the same host as Stella Mary Newton, the costume expert, and our conversation came round to the question of *The Fortune Teller*. Stella was gently but firmly full of warnings. She warned me that in the end the picture would be seen to be a forgery. Such an event would in her opinion be extremely embarrassing for me, as of course I could not defend having published it as genuine with the argument that I had formerly thought it to be false. It was this appeal to my conscience that provoked me into launching the campaign against the picture. In doing so I would have to attack myself, discredit my own ways of reasoning, admit that I had been wrong, and then suffer the indignity of being criticised for changing my mind.

It was almost too easy to discuss the problem intellectually in a friend's flat in Los Angeles. The arguments against the picture were clear enough in Stella's mind when it came to the costume. It was also easy to consider the whole thing in terms of conscience as well. After all, it should be the scholar's duty to say what he thinks. Yet talk was easy enough; it was very much more difficult to take action. Stella decided that she would help by going to see the new editor of *The Burlington Magazine*, Terence Hodgkinson, who had recently retired as head of The Wallace Collection and had been appointed as a short-term editor following Ben's untimely death.

I had already warned Stella that there was every likelihood that the whole affair would be referred back to Blunt immediately, as he had retained his influence on the magazine. Stella could not believe this as our meeting coincided with Blunt having been exposed as having been a Russian spy; he had, we were told, confessed in 1964 and been given immunity from prosecution. At that time (1979) there had been a virulent press campaign against Blunt in which all sorts of allegations had been made against him. It seemed surprising that in spite of the Queen removing his knighthood and despite the ensuing public disgrace, he should have continued in his positions of professional responsibility.

Stella was not the slightest bit worried about the possible interference of Blunt a second time. She revealed to me that back in 1969 when the doubts against *The Fortune Teller* had first been expressed Blunt had unsuccessfully tried to persuade her that the picture was authentic by exactly the same methods he had used against Diana de Marly, namely that stylistic arguments overrode those of the costume. It was in this optimistic frame of mind that Stella went to see Mr Hodgkinson.

Terence Hodgkinson is a noted specialist in sculpture, and he simply informed Stella that because of the nature of the problem he would refer the whole matter back to Blunt. She therefore retired, defeated, from that particular round of the battle. It is to Stella's credit that far from remaining an *éminence grise* she made her views known on the faulty costumes, and wrote to *The Times* to that effect.

I then decided to approach another periodical. I chose *The Connoisseur*. It had just come under the editorship of Will Allan

after Bevis Hillier had resigned. I had been writing articles for the magazine, albeit of a non-controversial nature. Will Allan's attitude took me by surprise. He suggested that Diana de Marly and I should write exactly what we pleased and then he would submit it to specialist libel lawyers and then publish it. Diana and I therefore revised our original article, as turned down by *The Burlington*. We found that in the intervening decade our basic ideas had changed but little.

All these negotiations and revisions took almost a year to the autumn of 1980. In the summer, Allan left and was replaced by the equally enthusiastic Paul Atterbury, who continued Allan's encouragement.

The joint article by Diana de Marly and me came out in September 1980. Our premises were simple enough. I attacked the picture on grounds of bad drawing, false signature and the presence of MERDE. Diana analysed the costumes very carefully, pointing out their inconsistencies and weaknesses. I could not resist adding one phrase which seemed appropriate and which has seemed to stick in the throats of the picture's defenders. I wrote that the picture was 'an insult to the profundity of French culture'. A second article followed in which I denounced both versions of *The Cheat* as possible forgeries.

What happened next took place extremely rapidly and involved a new set of people as well as a few of the already familiar ones. The attention of the art Press in Britain, France and America was turned towards the problem. The results were enlightening.

The first blow appeared in the November issue of *Apollo*. This took the form of an outraged letter from Sir John Pope-Hennessy (by then consultative chairman of the Department of European Paintings in the Metropolitan Museum). Pope-Hennessey's points were significant as he raised many different issues. He criticised Ben for having behaved irresponsibly over *The Fortune Teller* in the first place. He naturally defended the picture as authentic. He was careful to say that he had based his remarks on the examination conducted by the Museum's chief restorer, John Brealey. The article then concluded with an attack on my integrity as a scholar. *The Connoisseur* received a proof copy of this letter from *Apollo* and having taken pro-

fessional advice established that it was probably libellous. What had not emerged, however, was any new information, or indeed any arguments as to how the picture was supposed to fit into La Tour's oeuvre.

At exactly the same time the *Sunday Times* was conducting a costly and lengthy piece of investigative journalism. This was published in two articles which appeared in October and November and contained by far the most important amount of new information produced on *The Fortune Teller*. The two researchers were Colin Simpson, reporter for the *Sunday Times*, and Brian Sewell (then still an art-dealer but now pursuing a career as a journalist himself). Brian Sewell was not well disposed towards me because he was a long-time friend and staunch supporter of Anthony Blunt. He knew that I was totally unsympathetic to Blunt over his behaviour concerning *The Fortune Teller*. Sewell was therefore particularly suited to the job, as there was not the slightest possibility that he would be prejudiced in my favour. Indeed he later wrote an amusing but insulting article in *The Tatler* pillorying me while maintaining that *The Fortune Teller* was not by La Tour.

The methods used by the *Sunday Times* were meticulous. Brian Sewell and Colin Simpson interrogated me in detail about all the events which have been recounted in this book so far. Sewell's incisive mind soon picked on the inconsistencies in the story. The points which really interested him were the slightly far-fetched nature of the account of the picture's history from Solesmes and the apparently preposterous story of Patrick O'Connor. My side of the story as far as I had been personally involved was backed up with documents such as the letters from Dom de Laborde, Ben and all the art literature and journalism so far published.

A trip was made by the *Sunday Times* journalist to Solesmes and the surrounding area. Nothing turned up. Dom de Laborde had died and there seemed nothing to help them at Solesmes. The châteaux of La Denisière and La Vagottière seemed deserted, but a village postmistress told them that if there had been any pictures in the local châteaux they would probably have been taken away by the occupying Germans. This blank was not in itself a surprising result as Ben's and my only contact had been the monk.

Patrick O'Connor promised to be a much more fruitful line of enquiry. The interview took place by telephone, as O'Connor at the time was living in Palm Beach, Florida. I had visited him there on several occasions and each time he told the same story about M. Dion. To Brian Sewell's surprise O'Connor repeated his story almost word for word.

Proof of O'Connor's reliability in the matter of *The Fortune Teller* came when Brian Sewell found M. Albert Dion living in Corsica, where he was still restoring pictures. Dion was interrogated at length in his studio and produced an astonishing story, on which he kindly enlarged when interviewed for this book in December 1983.

M. Dion remembered *The Fortune Teller* well, as he had restored it in New York in the 1950s. It was in good condition, and he did not even need to re-line it. 'There was an old re-lining which was quite strong and we left it where it was. It was on a genuine stretcher.' He searched for, and generously handed over a picture he had taken of himself with the canvas in his studio. It was dated April 1958. Dion was explicit. He said that Georges Wildenstein watched him cleaning the picture, which was dark and yellow. This dirt was on the surface and presented him with no difficulties. 'At the time', he said, 'they used oil of copal, which preserves the painting quite well but yellows a lot. It came away easily.'

Though Monsieur Dion was referred to by that name by the *Sunday Times* and O'Connor, he now calls himself Dion-Delobre. He has great affection for his uncle, Emile-Victor-Augustin Delobre, whose portraits of his nephew and Mrs Dion-Delobre show him to have been an accomplished painter. In 1909 or 1910, according to his nephew, he was in the Louvre, copying a picture with his accustomed skill and accuracy, when Nathan Wildenstein (father of Georges) passed by. Stopping to look at what Delobre had done, he was so impressed that, there and then, he asked Delobre to come and work for him. The name Delobre was to reappear, sensationally, on another occasion in connection with another picture, though at the time of the *Sunday Times* story it was unknown to me.

The immediate problem was what was *The Fortune Teller* doing in New York some two years before it was exported from France. It must in effect have been smuggled out of France to be

restored in New York. The evidence for the picture having come back to France after this is meagre indeed. It is based on the fact that Brian Sewell says he saw a *Fortune Teller* in Paris with a dealer in 1958, but he cannot be sure that it is the picture now in the Metropolitan Museum, which was cleaned in New York in that same year.

What seems certain is that the picture in Dion's studio in New York in 1958 is the one now in the Metropolitan Museum. It has D I O N written on it, as has already been pointed out, and O'Connor distinctly remembered M E R D E. O'Connor's story was therefore proved in part by Dion's own statement. What is not clear is what exactly was done by Dion in that New York studio. Dion was explicit, stating that he only *restored* the picture. M. Pierre Rosenberg stated in the catalogue of the Paris exhibition of 1982 that the 'G. de La Tour Fecit Luneuilla Lothar' had been *strengthened*. That is enough from a scholar as eminent as M. Rosenberg to suggest that the 'signature' is not as La Tour would have left it.

M. Dion said that when he worked on a fine picture which was certainly by Rubens, Georges Wildenstein had pointed out that only the letter R was discernible as a signature. Since they knew the picture was genuine, Wildenstein asked Dion to complete the signature. This was an isolated instance, said Dion, who emphasised that he did not strengthen the signature in *The Fortune Teller*, whatever the Louvre chose to say.

When questioned about the M E R D E, Dion said that he believed it was original. He cleaned it as strongly as he could but it remained, though Georges Wildenstein was unhappy about it. Asked if he had put his name on the picture, he said: 'I wrote Dion? No! No, it is ridiculous. Even if I had put my telephone number on the painting, it remains that it is still by La Tour.'

His robust sense of humour was made plain by some of his paintings in his house and his studio: a virgin riding a unicorn, holding on to its horn, which takes the shape of a giant phallus; a couple embracing, forming the outline of Corsica, with raised arms threatening France, represented in outline by a naked rump; a *trompe-l'oeil* picture containing a torn envelope, of which all that is left of the address are the letters M (followed by a gap removed by the tear, then) C U L. Roughly translated, this means 'my arse'.

M. Dion restoring *The Fortune Teller*, April 1958.

Whatever one thinks of M. Dion, I feel sure that he did not forge *The Fortune Teller*. I remain convinced that the picture was painted ten years or so before he worked on it in 1958.

The evidence that Dion was restoring a picture which had been painted on top of another was to come later when the X-ray of *The Fortune Teller* was published in the following year. The area of conflict in the evidence is therefore narrowed down to the extent of Dion's work on the painting.

In the light of these findings Diana de Marly and I sought to broaden our arguments. We did this by writing separate articles on the issues posed by the picture. Diana made a careful analysis in *The Connoisseur* of the weaknesses in the costume structure of the two versions of *The Cheat*. The version in Geneva had at that time just been bought by the Kimbell Art Museum, Fort Worth, for the reputed sum of five million dollars.

My own article broadened the issue into the possibility that other pictures had been produced by the same stable of forgers. The arguments were based on stylistic similarities between the various pictures already pointed out by other authorities. For the two *Cheats* the arguments were simple enough because every authority had noted the similarities between the two *Cheats* and their undoubted relationship to *The Fortune Teller*.

The other pictures I named as possible forgeries were all prestigious, though none of them was an acknowledged masterpiece. A Sweerts (the rare painter of Genre scenes of the middle years of the seventeenth century) bought by the Louvre in 1967 had been related in its composition and models to *The Fortune Teller*, a fact that had already been recorded by the Louvre authorities. I added a so-called Frans Hals *Portrait of a Man* in the Fine Arts Museums of San Francisco which had been known since the 1920s though it had been discredited as a Frans Hals by Seymour Slive, the authority on the subject.

Neither of these two follow-up articles were taken up by the Press, which still concentrated on the issues round *The Fortune Teller*. In this area for example there were some reactions from Brian Sewell. Although his article in *The Tatler* was of a frivolous nature it contained some sound art-historical arguments. He maintained quite correctly that commentators had not stated the subject of the picture accurately, as what was depicted was the action of a procuress. This further revealed the forger's incompetence, because he had dressed his women, incorrectly, as gypsies. Sewell maintained that the picture was not an authentic La Tour, although he challenged the validity of my reasons for doubting it.

There were other reactions at the time, one of them coming from *Private Eye*. They had conducted a campaign against Blunt before the admission by the Prime Minister that he had been guilty of espionage. They also had in their possession the information contained in the unpublished article written by Diana de Marly and myself which had been given to them in 1969. They asked me if I had any further information concerning the whole affair. I was able to point out to them Blunt's proven connection with Georges Wildenstein. This dated back to 1947 when Blunt organised for his Bond Street Gallery an exhibition of French seventeenth-century painting. Significantly, one of the pictures included in the exhibition was wrongly attributed to Georges de La Tour: it was in fact a Flemish work close to the work of the Antwerp artist Gerard Seghers. Blunt was also on the editorial consultative committee of Wildenstein's *Gazette des Beaux-Arts* (and would be in a position to vet any undesirable material submitted to that periodical).

This connection with Georges Wildenstein gave Blunt a motive for defending the interests of his colleague and former employer.

The week following the *Private Eye* article an embarrassing letter appeared in Blunt's defence. It was written by Alistair Laing who noted that Ben's and my book had been dedicated to Blunt, and was therefore proof enough of our respect for him. What in fact had happened was that Ben had somewhat deviously suggested that we dedicate the book to Blunt in order to prevent him from reviewing it. For those who think that this might have been out of character for Ben it is worth noting that his obituary writer in *The Times* described him as both 'innocent and wily'. The rest of Laing's letter was provocative because he added that in his opinion it was perfectly legitimate for Blunt to use his influence over *The Burlington* to suppress an 'unripe hypothesis'.

Blunt was in fact defended by several of his former pupils who wrote letters to *The Times*, stating among other things, that he was a 'scholar and a gentleman'.

On the face of it, especially following the articles in the *Sunday Times*, the position of *The Fortune Teller* as an authentic La Tour looked weak indeed. The Press had been taking the attitude that there were good grounds for the picture being treated with suspicion and many academic colleagues, when asked their opinions, tended to feel that something was indeed wrong with the picture even though they were not willing to come to my aid with a supporting statement in public.

At this crucial stage when it seemed to me that the case against *The Fortune Teller* was half-won there entered an important new element. This was the interest of two different television companies – the BBC and the American CBS network who prepared a programme for their Sunday evening show *60 Minutes* which is especially popular in America owing to its concentration on matters which are of a controversial nature.

The CBS staff in London took their task very seriously and they employed a qualified art historian to sift through the vast amount of journalistic material which had by then accumulated, as well as the information I had thus far assembled. They asked me numerous difficult questions about why I

changed my mind under pressure and were especially detailed about how each piece of information had come to light. Then they brought over their interviewer Morley Safer, and in front of life-size photographic replicas of the two *Cheats* and *The Fortune Teller*, Diana de Marly and I were able to summarise our main points of criticism against the picture. Other people in Britain were also interviewed by the CBS who spoke against the painting. Sidney Sabin, the art dealer who had exposed the affair of the Boston 'Raphael' by denouncing it as a forgery in the pages of *The Times*, reiterated his views against *The Fortune Teller*, pointing out the total incompetence of the drawing. (He had written to me as long ago as 1972 expressing his opinion that *The Fortune Teller* was a forgery.)

Brian Sewell was also interviewed and he was perfectly sure that the picture was not by La Tour. As far as CBS was concerned this made a case worth broadcasting.

The greatest problem faced by CBS was with the Metropolitan Museum. They threatened to bring legal action against CBS if they broadcast the programme (which would have been seen by some 60 million viewers, so popular is *60 Minutes*). At the same time they were not prepared to answer the questions the *60 Minutes* team wanted to put to them. Already there were enough inconsistencies accumulated to require some urgent answers. Had the picture ever been restored during its twenty-year-long stay in the Met? Had there been a proper scientific analysis, and if so what were the results? What was the Museum's version of the picture's history? What was the status of MERDE, in the Museum's opinion?

What made the Metropolitan Museum look all the more peculiar in its position is that they had co-operated with another television company, and had been most generous with their professional opinions, at the same time revealing a whole new series of facts about the picture. This was for the BBC in a programme made by Edwin Mullins.

The original cause of Mullins' involvement was a chance comment in the *Sunday Telegraph* back in the summer of 1980, before the appearance of the *Connoisseur* articles. It was stated that the BBC was about to embark on an ambitious series called 'One Hundred Great Paintings', where each ten-minute programme was to be devoted to the study of one picture. This

turned out to be an acid test for both pictures and commentator. Some of the programmes were excellent in their own right, while others descended rapidly into bathos. Edwin Mullins noted in the newspaper article that he was happy to have included two works by La Tour, one of which was to be *The Fortune Teller*. In itself this was a surprise because even the picture's most ardent supporters could hardly suppose that it ranks amongst the world's greatest pictures.

I telephoned Edwin Mullins immediately and sent him a typescript copy of the article by Diana de Marly and myself which was by then about to appear in *The Connoisseur*. He showed great interest in our findings but did not react one way or the other. The *Evening Standard* however published a sarcastic little comment that the BBC's hundred great paintings were about to be reduced to ninety-nine.

Edwin Mullins and his team produced a film about *The Fortune Teller* which they entitled *Fake*. It was broadcast in the summer of 1981, in an entirely different format from the CBS programme. Instead of the neutrality of the studio and a reproduction of the picture to talk from they insisted that Diana de Marly and I put our case against *The Fortune Teller* in the form of an interview filmed at home. While this may give an intimate feeling for the viewer, it is in fact much more difficult to deal with when one's small room is aflood with technicians.

The questions we were to answer were not provided in advance and neither Diana nor I were permitted to make out our case in a logical and ordered way. Instead, there were several hours of filming in which we were required to answer Edwin Mullins' questions. When the film was broadcast these questions were removed, thus giving the impression that we were attempting to make out a carefully argued case. Those who have broadcasting experience will know that in an interview it is essential to answer the question since any attempt to alter the question gives the impression of evasion. Both Diana and I felt that what was broadcast, although cut up, remained fairly representative of our views. Our source of regret was what was *not* said, and that turned out to be crucial.

Mullins set out to prove the picture genuine and in his quest he came up with what seemed to be the most startling revelations so far. Logically speaking, all that had to be done

was to prove on the basis of scientific analysis that the picture was earlier in date than the present century, and that it had a history reaching at least some distance back into the past. If this could be established then the picture returned to the limbo of academic dispute over seventeenth-century attribution. It would therefore cease to be dramatically controversial. Many celebrated pictures have undergone changes of attribution at the hands of scholars but remained undiminished in the public eye as masterpieces.

The fact that Edwin Mullins believed *The Fortune Teller* to be a masterpiece was implicit in his enquiries, and this eventually came out in a second, altered, showing of the *Fake* programme, which was followed by his own ten-minute adulation of the picture as one of the last in the series 'One Hundred Great Paintings'.

Edwin Mullins kept his enquiries totally secret from both Diana and me, and only when the filming was complete did he return and ask us to comment, unprepared, in front of the camera. We had only thirty seconds of television time to refute the case made out against us. This method was in academic terms underhand, but is I assume legitimate for media purposes. The academics and journalists in opposition had the advantage of being able to read in print exactly what Diana and I thought was wrong with *The Fortune Teller* before they set about defending it.

Edwin Mullins had been to Solesmes where he came across an incredible amount of new information. It appeared that the papers of the late Dom de Laborde were available for inspection, although they had eluded the *Sunday Times* investigation of a few months before. What Edwin Mullins found in going through the papers proved to be the most important break through in the apparent history of *The Fortune Teller* so far. Mullins concluded that after Ben and I had visited him and he had corresponded with us in 1972, Dom de Laborde had come across very much more precise information about the former whereabouts of the picture. Dom de Laborde had been given access to the papers of the de Gastines family and in these papers, apparently, it was recorded that they had owned a La Tour as early as 1879, when an inventory was drawn up at the time of the death of a member of the family. This entry, the

original of which was later produced by M. Celier himself, read *'Item, un tableau representant La Bonne Aventure, signé Georges de La Tour'*.

Ever since this document became known, first in the television programme and later fully published in *The Burlington Magazine* by Pierre Rosenberg, it has been assumed that *The Fortune Teller* is the very picture which appeared in the 1879 inventory. This identification hangs on the memory of M. Celier who stated before the television cameras (though not in print) that he remembered *The Fortune Teller* as a child in the period before the second world war. This would take the picture back to the 1920s. This statement presents more problems than it solves.

The existence of *The Fortune Teller* prior to 1945 is attested by the recollections of M. Celier alone. Even for the period 1945–1960 the picture's whereabouts has only been reconstructed with great difficulty. *The Fortune Teller*'s possible existence in the 1879 inventory puts the idea of modern forgery in jeopardy. M. Celier was adamant that the painting was indeed the one in the inventory. He produced an old photograph taken at the time the painting was rediscovered by himself just after the end of the war in his uncle's château, exactly as had been recounted by Dom de Laborde in 1972. The production of this photograph worried me, because it showed that the painting was *clean* at the time of M. Celier's identification.

Anybody who is used to looking at old master paintings, even those which are carefully looked after in museums, knows that varnishes yellow very quickly; M. Celier's 'find' had in any case been in a château occupied by the Germans during the war. It was therefore inevitable that the picture had been cleaned not long before M. Celier's discovery.

The most important question which Edwin Mullins did *not* ask M. Celier was about the existence of MERDE. The elderly gentleman's memory was very clear on certain points. He stated that as a child he had been frightened by the old crone on the right of the picture, but he avoided mentioning the existence of the dirty word, which surely would have amused the average schoolboy. M. Celier's silence on the matter was especially disappointing. If MERDE was indeed on the picture it

is difficult to believe that nobody had noticed it, especially Dom de Laborde, who had the picture under his scrutiny at Solesmes for a considerable period of time.

If on the other hand MERDE was not on the picture during this period it must have been added at a later date. To suppose that it was put there by the Metropolitan Museum is foolish and incorrect: photographs prove that the inscription was already there at the time of the picture's acquisition in 1960. This would only leave the period when the picture belonged to Georges Wildenstein. Again that such a well known dealer should consciously have done such a thing to a valuable picture has to be ruled out. Yet the Metropolitan Museum is adamant that MERDE was a modern addition.

The problems of M. Celier's brief statements do not end over the mysterious MERDE. In turning to the mention of the picture in the inventory (as 'La Bonne Aventure'), the proper translation is *The Good Fortune* rather than *The Fortune Teller*. We have to accept, therefore, that the maker of the 1879 inventory saw in the de Gastines château a painting with a La Tour signature which he gave the title *The Good Fortune*. This is indeed a very odd title to give the picture, which in any case represents a procuress rather than a fortune teller. Its true setting is not a gypsy tent or caravan but a brothel.

The most often repeated argument in favour of the Met's picture being the one in the de Gastines inventory is the fact that at the time the personality of Georges de La Tour was still completely unknown, and it would have been pointless for any unscrupulous person to bother to fake a La Tour. We have to accept, therefore, that if the document produced by M. Celier is authentic it records what should have been an authentic La Tour. We still have only his word that it is indeed the same picture. I believe him to be honestly mistaken. If his picture was clean in 1948, there would be no need for Dion to clean the same picture and remove oil of copal (which is not a modern preservative) only ten years later. There must be another explanation.

In fact the painting was about to present far more problems than even I had anticipated after the new information was revealed by the Metropolitan Museum.

When Edwin Mullins went to the Met to film he interviewed

three experts concerning their views on the authenticity of the painting. This was the first time in the history of the Met's ownership of the picture that they had been prepared to go on record with *any* real information, bearing in mind how Ben and I had been treated on our visit and how the CBS had been denied an interview.

John Brealey gave Edwin Mullins the typescript of his forthcoming note in *The Burlington Magazine* (a piece of information denied to both Diana and me, even on the point of being interviewed a second time). Now for the first time the arguments became technical. Mr Brealey was at that very time restoring *The Cheat* from the Geneva private collection for the new owner, the Kimbell Art Museum, Fort Worth. He was able to compare the two paintings in his studio for the benefit of the television audience. During his interview he made a series of statements. The first was disturbing. He said that *The Fortune Teller* and *The Cheat* produced very similar X-ray results. This would of course be expected if the pictures had been by the same artist and painted about the same time. Yet this was emphatically not the case, because when the X-ray of *The Fortune Teller* was published in *The Burlington* it revealed, sensationally, that there were the very considerable remains of a different picture underneath it!

The X-ray of the Fort Worth *Cheat*, on the other hand (which I was able to examine in great detail thanks to the Museum authorities), reveals no such different composition, only a curious method of underpainting with broad sweeps of the brush.

What disturbed me most was that John Brealey emphatically denied that the X-ray of *The Fortune Teller* revealed any different composition underneath, and later made this statement in *The Burlington*. His next statement was even more bizarre. He explained the existence of MERDE by saying that it was in his experience for restorers to put even such objects as bicycles in the backgrounds of the paintings they restored.

The other two people interviewed were equally sure of themselves. Dr Peter Meyers, who was responsible for the chemical analysis of the picture, stated that everything he had found was entirely in order for a picture dating from the first half of the seventeenth century. The costume expert believed in

her analysis that *The Fortune Teller* bore close similarity with other pictures by La Tour and that proved its authenticity as far as she was concerned. Yet it is a fact, even if there is disagreement about Diana de Marly's conclusions from those facts, that *The Fortune Teller* is substantially different from any of La Tour's authentic night scenes.

Edwin Mullins then invited Professor Michael Kitson of the Courtauld Institute to act as a mediator on the whole programme. Kitson came to the conclusion that I was wrong, basically because he was impressed by the weight of evidence on the other side. The first showing of the programme aroused a good deal of critical comment in the Press. The reviewers came to the conclusion that neither side had proved its case. Brian Sewell produced an attack on Edwin Mullins in *Art and Artists* where he pointed out that Mullins had used obviously journalistic methods against an art historian which did not help the cause of truth.

Diana de Marly and I had to wait until the evidence we had seen used against us on television was properly published in *The Burlington* before we could assess it in detail. The first publication was the joint article by John Brealey and Peter Meyers, which we knew of but had not seen. Apart from the X-ray, the greater part of the article was taken up with a complex series of chemical formulae, with the ultimate conclusion that both the canvas and the paint were old. In order to explain their case in more detail one argument was given prominence.

This was the fact that the picture was painted with lead tin yellow – a fact I already knew from Von Sonnenburg's findings of ten years before. Brealey and Meyers argued that as lead tin yellow had fallen out of use as a common pigment at the end of the seventeenth century and had only been rediscovered in recent years, this was proof enough that the picture was of early origin because it could not have been made in the intervening years. This argument is quite simply incorrect. It was discovered some years ago that lead tin yellow was in use in the eighteenth century too. The authorities in the Mauritshuis in The Hague made up the pigment from a recipe book published in Germany in 1783. They then tested the newly-made pigment and found that it had just the same chemical structure as the lead tin yellow used by Rembrandt.

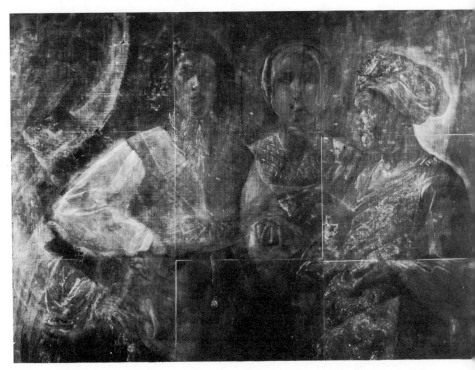

X-ray of *The Fortune Teller*. Note the clear image of a different single profile on the left, itself superimposed on part of another face, extreme top left hand corner.

A reconstruction of the single figure and profile revealed by the X-ray.

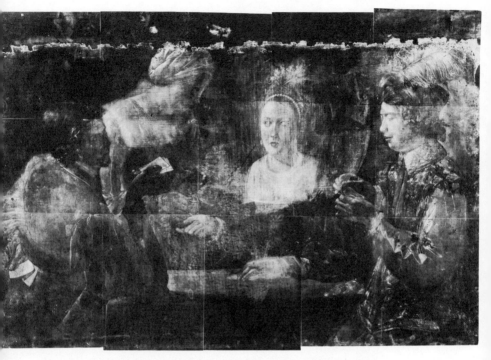

X-ray of the Fort Worth *Cheat*. The X-ray image shows the building-up of layers of light paint in the flesh tones, as would be expected in an old master painting. In *The Fortune Teller* X-ray there is no such structure apparent.

Suggested correction to the left-hand figure[s] in *The Fortune Teller*.

This was an especially important finding on two counts. First it showed that the Met's argument that the lead tin yellow proved the early origin of the picture was wrong. Second, and more sinister, it showed that by exactly following an old recipe it was possible to produce pigments in modern times with the same chemical structure as those used in the seventeenth century. Pigment analysis could, in this respect, only be used as an imperfect adjunct in verifying the period when a picture was produced. Where chemical analysis proves extremely useful is when the painter of a picture introduces a chemical pigment only known from a certain date. Forgers can still safeguard themselves from exposure by this method of scientific analysis by following, scrupulously, old recipe books for their colours.

Nowadays much more sophisticated methods are used in establishing the date of objects. One of them is carbon dating, by which means it is possible to tell whether a canvas is of old or modern origin. Forgers get round this by using old canvasses. Proof that scientific analysis has a long way to go is the fact that when the *attribution* rather than the dating of a picture is in dispute there is very little that science can do. What the Met had managed to prove over *The Fortune Teller* was that it was not chemically or physically incompatible with a seventeenth-century date. They had not taken into account the possibility that a modern forger could make, or the certainty that he would try to make, a picture which would pass these tests.

At this stage, the general public was faced with conflicting views: the result of the *Sunday Times* investigation and the approach of the BBC and CBS programmes. Both sides had produced a good deal of essentially conflicting information. Much of this centred on the history of the picture's restoration or restorations. Dion had admitted to restoring it, but nobody else was willing to confirm or deny that fact, which would lead to embarrassing questions being asked about the origin of MERDE.

The sensation of the second showing of the programme *Fake* in 1982 was this removal of MERDE. Brealey stated that it had been added in the embroidered shawl by turning the embroidery into letters. He removed the letters, stating them to be modern. In the previously published chemical analysis there had been no record of *any* part of the painting being of modern

origin. I had written to the BBC suggesting that I should meet my antagonists in a round table conversation in order to discuss all the problems raised (rather than solved) by the new findings. Though this would surely have made dramatic television, they declined. Instead, Edwin Mullins referred yet again to Professor Kitson, who brought up the question of the X-ray by saying that it was normal for a seventeenth-century artist, especially Caravaggio, to make changes as he continued painting the picture. This is quite true, but irrelevant: I believe that the X-ray does not reveal artist's changes but *another picture*, possibly a nineteenth-century (or earlier) original, on which the picture has been based.

Fortunately the matter did not end here. There were a few protests in my favour. Brian Sewell wrote a detailed letter to *The Burlington*, outlining various inconsistencies in the arguments of Brealey and Meyers. Stella Newton wrote to *The Times* stating what was wrong with the way the so-called gypsies were wearing their costumes. Then Bevis Hillier, former editor of *The Connoisseur*, did a short piece for *The Times* summarising the position so far. The result of this was that Professor Kitson wrote a letter of protest to *The Times* in which he stated that I should not 'continue to mislead the public'. This was a strange statement bearing in mind that my only public pronounce-ments on the subject were my arguments in *The Connoisseur* articles and the television interviews already recorded. Kitson also castigated Brian Sewell for involving himself irresponsibly in the controversy.

Professor Kitson's letter in defence of *The Fortune Teller*, and praising John Brealey's cleaning of it, was of considerable importance. It was the first time an art historian had committed himself to print (apart from Rosenberg's publication of M. Celier's document in *The Burlington*) in defence of the picture. Kitson's letter provoked a further letter, this time from Professor Rees-Jones, who had for many years been in charge of the technology department of the Courtauld Institute. The gist of his letter was that on the evidence produced so far it was perfectly plausible for a forger to have produced such a picture as *The Fortune Teller*. The most telling piece of evidence was in fact the X-ray.

All the evidence so far accumulated by The Metropolitan

Museum was presented when *The Fortune Teller* was exhibited in Paris early in 1982 in an exhibition of French seventeenth-century paintings from American collections. The exhibition then went to the Met and on to Chicago. It was therefore seen by an enormous number of people. The catalogue was by Pierre Rosenberg, who was careful to summarise all the arguments put forward by the Met and then stated that he accepted the picture as authentic based on their findings.

Rosenberg added a few interesting observations of his own. MERDE had been put there by *malicious* intent (even though he had not been able to see it ten years before!). A direct accusation was, therefore, being made towards . . . somebody.

Of much greater importance was Rosenberg's comment that the signature had been 'strengthened'. Such a statement places doubt in the mind of the spectator without being precise. In fact careful examination of the signature on the picture itself shows that the dark pigment goes *over* the craquelure (the name normally used for the cracking of the paint), suggesting that it was added very much later than the picture was painted.

The most significant new fact of all is the X-ray. Instead of the two badly drawn and confused figures on the left of the picture, there is the ghost of a single figure seen in profile in an entirely different position. The only part of this shadowy figure underneath which relates to the present surface of the picture is the sleeve, which occupies the same position. What can we make of this important piece of evidence? That La Tour changed a single and perfectly logical figure into two confused ones? On re-examination of the painting it seems that the sleeve reflects what was originally there. A likely explanation is that a genuine old picture was turned into a La Tour by scraping down those parts of the composition which were unwanted, and then reconstructing the picture. By such a method the canvas remains old and the 'changes' are reduced to a minimum instead of starting from scratch. This hypothesis is further helped by looking at the image of the young cavalier in the centre. The figure was originally in a different position, much higher up, and was originally wearing a different type of uniform as indicated by the sash going in a different direction from the right shoulder which was originally much higher.

The original composition, which had *The Fortune Teller*

painted on top of it, is also visible in the background. There are traces of a curtain upper left and what appear to be further traces upper right. Most astonishing are what appear to be the remains of a face looking straight at the spectator, high on the left.

Should we conclude from this that Georges de La Tour was a bungler, erasing curtains and turning one figure into two in order to achieve an incompetent piece of drawing? The X-ray of the Louvre's *Christ in the Carpenter's Shop* reveals a very different character for the real La Tour where it is clear that the magical effect was achieved by the painting of layer upon layer of light paint on a dark background. In *The Fortune Teller* X-ray there are no such layers, only a removal of one composition before placing another over it.

The X-ray is therefore one piece of evidence produced by the Met which reveals the tell-tale signs of a forger at work. Van Meegeren, perhaps the most successful of known forgers, used the starting-point of an old canvas too. He did not scrape it down well enough and the original composition showed up when his forgery was X-rayed. In *The Fortune Teller* rather more is left of the original canvas than usual on these occasions. What seems surprising is the clumsiness in the way it was done. The old crone's shawl is demonstrably a mess, as the whole structure of a woven textile was ignored at the same time as painting every stitch. The positions of all the figures have been altered except that of the old crone. All this is incompatible with La Tour's known authentic work.

CHAPTER 6

The pictures related to The Fortune Teller *are discussed as forgeries and other spurious 'La Tours' are questioned.*

THE TWO *Cheats* must now be examined in detail in order to assess their precise relationship to *The Fortune Teller*. M. Landry's *Cheat*, bought by the Louvre in 1972, contains no clue as to its possible authorship by a modern forger because the only inscription on it is the *Georgius de La Tour* signature (see p. 59) which bears some relationship to the signatures found on authentic La Tours such as *The Dream of Joseph* at Nantes.

The Louvre *Cheat* was used by Pariset and others as the lynchpin of their argument as to why *The Fortune Teller* was by La Tour. It is my purpose to demonstrate that this version of *The Cheat* cannot be by La Tour and that it is simply a weaker variant of *The Cheat* now in the Kimbell Art Museum, Fort Worth. Ironically, the authorities of the Fort Worth Museum validate their picture as by La Tour by means of its similarities to *The Fortune Teller*!

Proper analysis of the relationship between the two versions of *The Cheat* is now possible owing to the fact that the Fort Worth picture has been cleaned, although its restoration by John Brealey means that there is a good deal of his handiwork on it owing to the fact that there are some losses of paint clearly visible in the photographs of the unrestored picture.

The Fort Worth *Cheat* bears no signature or inscription of any kind and there are no traces of any inscription visible on the X-ray. Until Pariset attributed it to Georges de La Tour in his book in 1948 the picture had remained in obscurity in the collection in Geneva. It was only through pressure brought by Ben and myself on the exhibition committee in 1972 that the picture was brought to Paris at all, because it had been clear to me all through my research on La Tour that no authority had taken Pariset's attribution of it to La Tour seriously. The only two pieces of evidence for the picture's existence at all were

Sterling's chance comment in 1934 that there was another version of M. Landry's *Cheat*, and Pariset's poor reproduction of 1948 although in the catalogue of the La Tour exhibition held in 1972 it was stated that M. Landry had studied the picture in 1932.

At that time the picture was indeed in a disconcerting condition. It was disfigured with numerous old repaints and was reproduced with these disfigurements in our book. It was not taken up as a major new discovery at the time because M. Landry's version was in the limelight.

In order to demonstrate that the Louvre picture is an inferior work based on the Fort Worth picture it is essential to consider the evidence. Because there is no signature, and the history of the picture in the Pictet family does not go back far enough to help, discussion of the picture has to be based on stylistic analysis – in other words old-fashioned connoisseurship. The scientific analysis of the painting so far conducted consists of an X-ray which, it has already been noted, produced no disconcerting results.

It is an essential part of the whole methodology of art history, and in particular of the connoisseur's side of the discipline, that 'new' pictures have to be compared to all the available evidence in the form of other surviving pictures. For the Fort Worth *Cheat* the main objections lie in the lighting, the two-dimensionality of the picture, and in the curious formations of the jewellery, especially the bracelet of the serving maid, which looks oddly like an expanding wrist-watch strap. Equally disconcerting are the curious patterns on the dupe's collar on the right. On the other hand, the composition makes sense as a seventeenth-century subject usually identified as 'the prodigal son dissipating his patrimony'. The Church at the time forbade images of gambling and low life unless they could point to some moral.

The historian, faced with the Fort Worth *Cheat* as a unique object, has then to analyse all the contemporary trends in La Tour's Lorraine in order to see if there is any possibility of placing the picture at that time. This has to be done with extreme caution, as the danger lies in comparison with the other two problem pictures. Taking pictures which have been known since the seventeenth century one of the most important ones is a *Banquet of Herodias* in the Collegiate church at

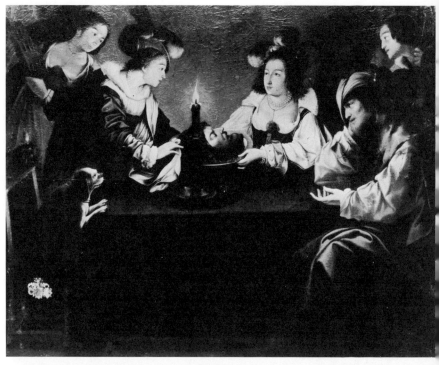

Jean Le Clerc, *Banquet of Herodias*. 180 × 225 cm. Eglise Collègiale, Chaumont. A rare example of a painting by a contemporary of La Tour showing similar characteristics.

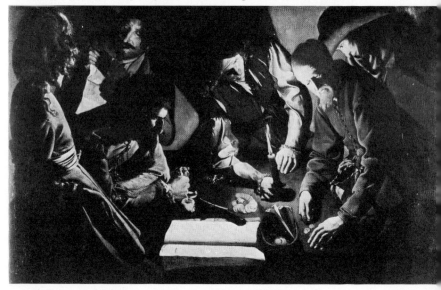

The Payment of Dues. 99 × 152.5 cm. Lvov Museum, USSR.

Jean Le Clerc, *The Concert Party*. 136 × 170 cm. Schloss, Schleissheim.
La Tour and Le Clerc were close in style in the early 1630s.

Chaumont (Haute-Marne), which has been there since about 1630. It is attributed to the Lorraine court artist Jean Le Clerc who died in 1633 (nineteen years before La Tour). It is the only surviving evidence of this type of picture in Lorraine.

The Fort Worth *Cheat* is not copied from the Chaumont picture, though the basic elements are the same. The elaborately dressed figures are in similar positions round the table and there is even a lighted candle. There is also some evidence of the relationship between La Tour and Le Clerc, as Le Clerc's other major surviving picture, *The Concert Party* (recently transferred from the Residenz at Munich to the Schloss at Schleissheim), was engraved by the same engraver who did the three compositions after La Tour. It was Pariset's hypothesis, not since accepted, that it was Le Clerc himself who did the four engravings. Stylistic closeness between Le Clerc and La Tour is even stronger when the Lvov *Payment of Dues* is compared to Le Clerc's *Concert Party*.

If we examine the Fort Worth *Cheat* closely in this context then it emerges that the face looking down in the centre of the

Lvov picture resembles at least superficially the cheating figure on the left of *The Cheat*. As this model appears in no other picture (apart of course from the other *Cheat*) it is reasonable to consider that the two pictures may be related to one another. The Fort Worth *Cheat* therefore relates both to Le Clerc (the Chaumont *Herodias*) and to La Tour (the Lvov picture). It is on these somewhat tenuous grounds of visual comparison that the case has to rest in favour of La Tour's authorship.

When we now turn to look at the Louvre *Cheat* in detail and compare it with the Fort Worth picture, differences appear.

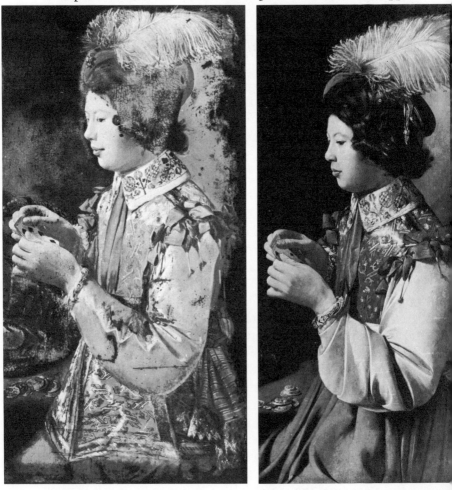

Detail: dupe on the right, Fort Worth *Cheat*.

Detail: dupe on the right, Louvre *Cheat*. Note the muddled costume and poorly painted feather.

Diana de Marly started on the costumes pointing out that there were serious discrepancies between the two versions. Starting with the figure on the right it is obvious that in the Fort Worth picture he is wearing an elaborately decorated jacket which finishes above the knee. In the Louvre version the decoration stops abruptly half way down and the garment changes into an elaborately folded heavy material of a different colour and texture. In other words the garment in the Louvre picture seems to have been *invented* and not observed. The courtesan in the centre of the picture is equally telling in terms of structure.

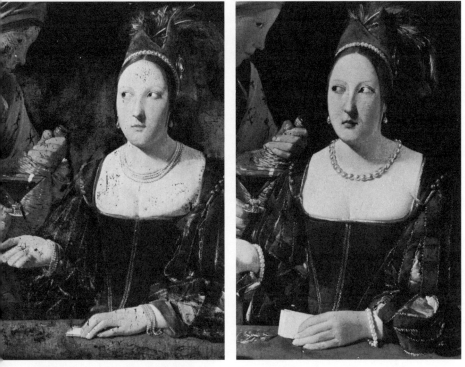

(left) Detail: courtesan, Fort Worth *Cheat*.

(right) Detail: courtesan, Louvre *Cheat*. The courtesan's necklace falls unnaturally, apparently raised behind her left shoulder.

In the Fort Worth picture she is covered with elaborate jewellery but in the Louvre version that jewellery ceases to make sense as it looks as if it will slip down her bare shoulders. Diana de Marly notes that the headdress in the Louvre picture is illogical and certainly does not have the same easily visible structure as in the Fort Worth picture.

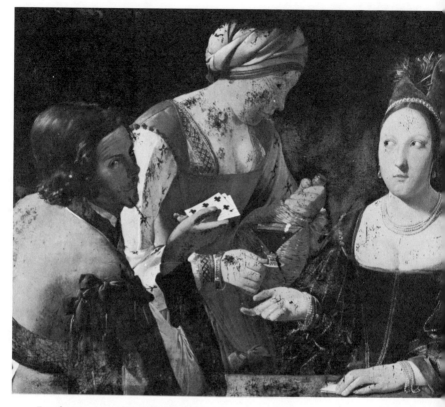

Detail: serving maid, Fort Worth *Cheat*.

The greatest inconsistencies are however found in the serving maid. The model in the Fort Worth picture looks like a rather younger version of the same model who appears so movingly as Job's wife in the Epinal picture. In the Louvre picture the structure of her dress stops half-way down and turns into a blob of red instead of a carefully structured skirt. The game is given away, however, by what has been added. The Louvre serving maid has been given an aigrette. This became fashionable in Paris in the years immediately after 1910 after the appearance of the *Ballet Russe* there. Its presence raises questions of the absurd. Seventeenth-century serving maids did not wear aigrettes. The cheat himself is the least misunderstood part of the Louvre version of the picture, although the knots at the shoulder in the doublet are reduced to meaningless pieces of ribbon.

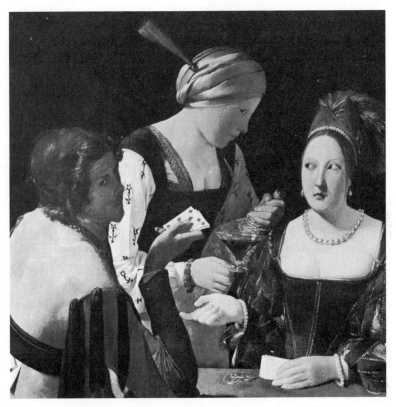

(right) Detail: serving maid, Louvre *Cheat*. Apparently copies from the Fort Worth picture, with addition of an early twentieth-century aigrette.

The defenders of the Louvre picture as a La Tour have now got to accept that La Tour repeated himself yet made a host of *misunderstandings* moving from one version to the other. Sterling's arguments as long ago as 1934 were extremely interesting. It was Sterling who noted that the lower part of the garment in the dupe on the right was related to the drapery of *The Hurdy-Gurdy Player* in the Nantes Museum, a picture which he was about to attribute so controversially to La Tour. In other words the major difference between the two versions was that the weaker version was looking *more* like pictures which Sterling was (quite wrongly) going to attribute to La Tour.

The hypothesis is therefore, that the Louvre version of *The Cheat* was painted as a 'La Tour' sometime before 1932, basing itself on the unsigned picture in the Pictet Collection in Geneva. Comparison between the two pictures with this hypothesis in

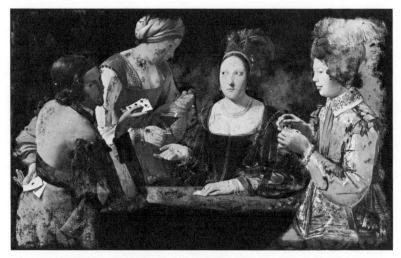

The Cheat. Kimbell Art Museum, Fort Worth.

mind yields some surprising results.

The Louvre *Cheat* has some unmistakably 1920s qualities about it. Apart from the offending aigrette, the courtesan has a certain 'flapper' look about her make-up. The differences between the two pictures in their facial expressions are subtle enough but they are at the same time sufficient to show that the Louvre *Cheat* has little to recommend it as a seventeenth-century picture. It is a weaker version, with a good number of misunderstandings introduced, of the Fort Worth picture.

If we now consider the chronology of the three pictures as so far known it becomes easy to see how one spurious picture was used to authenticate another.

1960 *The Fortune Teller* is bought by the Met with the Landry *Cheat* authenticating it by comparison.

1972 The Landry *Cheat* is bought by the Louvre, authenticated by comparison with *The Fortune Teller.*

1981 The Geneva *Cheat* is bought by the Kimbell Art Museum, Fort Worth, authenticated by comparison with *The Fortune Teller* and the Louvre *Cheat.*

My solution to this Chinese puzzle is that two forgeries were made, one in the 1920s and one in the 1940s, both based on a dubious picture in a respectable Swiss private collection. Seen in isolation, the Louvre *Cheat* has a certain 1920s air as does

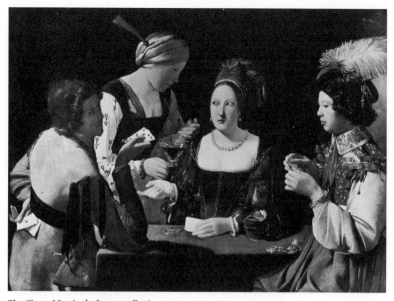

The Cheat. Musée du Louvre, Paris.

The Fortune Teller seem reminiscent of the 1940s. Neither of them relate convincingly to La Tour.

The damage done to La Tour's reputation during his rehabilitation in the 1930s by the insertion of *The Cheat* did not end there. It was M. Landry and Charles Sterling who were responsible for the identification of La Tour's daylight period. They did not discuss the Geneva *Cheat*, but concentrated on attributing to La Tour a group of pictures scattered in the various museums of France which had until that time been attributed to various other masters. It was only on their relationship to the Louvre *Cheat* and to no other picture that the arguments rested. The point about the Nantes *Hurdy-Gurdy Player* draperies has already been made. This group of paintings, to which a few more have been added in recent years, contains no works which I consider to be forgeries. They will gradually return to their old labels as anonymous Spanish, Italian or French school until one day the correct attribution will be found. The Nantes picture had been attributed to Velasquez, Zurbaran and Caravaggio. The moving *Hurdy-Gurdy Player* in the museum at Bergues near Dunkirk had been attributed to the Carracci as long ago as the late eighteenth century.

Not one of the pictures in this group is signed, dated or documented as a La Tour. There is therefore no good historical reason for giving them to La Tour at all. One of the best is *The Beggars' Brawl*, bought by the Getty Museum in 1972 on the authority of Ben and myself as a La Tour. The change of attribution, and its temporary placing in the limbo of 'anonymous', cannot detract from its undoubted quality as a work of art. Indeed it is a paradox that this group of pictures is of the highest order. They are all characterised by a brutal realism: in the Berlin picture poor peasants eat beans, all the hurdy-gurdy players are blind, at Stockholm and Grenoble the images of St Jerome show him in the act of self-flagellation. Without *The Cheat* to link them to La Tour they gain in stature as a quite coherent group. Their loss to La Tour means that our interpretation of him re-focuses, making him again a painter who was at once more mystical and more provincial.

The forgery of night scenes by La Tour has undoubtedly taken place, but they are sometimes confused with genuine pictures wrongly attributed to La Tour. The group of pictures which I believe to be by Etienne de La Tour, one of which is signed, has been isolated at the beginning of this book. Most of them are characterised by the fact that they are replicas of La Tour-like compositions, exactly as would be expected from an active studio. The forger seeking to make his fortune seldom paints any such 'replica' because it will always be in the shadow of the original from which he has had to take his inspiration.

It therefore becomes ever more necessary to purge La Tour's art of the forgeries which have become accepted as original masterpieces. A few of these pictures found their way into the 1972 exhibition and have, as a consequence, been accepted as by La Tour ever since.

The most painful of these was the Wrightsman *Magdalen*. It had not until that time been exhibited, having been discovered, according to Pariset, in 1961. My own doubts about the picture concerning the mirror frame (see pp. 83–4) did not resurface until I was able to examine the picture again recently in the Metropolitan Museum of Art, to which institution the Wrightsmans had given it.

In general terms what is wrong with *The Magdalen* is that the

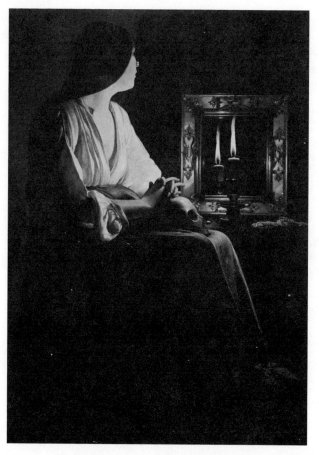

The Magdalen. Metropolitan Museum, New York.

painter has misunderstood the seventeenth-century way of seeing, exactly as film makers inevitably show up their own times as much as the period which they are trying to recreate. One reason for this misunderstanding of the past, both in forgers and in film makers, is that they are trying to appeal. They must sell their wares, and must strike a chord which will echo in their own time. As soon as a few years pass the work becomes 'dated'. This is exactly what has happened to the Metropolitan Museum's *Magdalen*. The model lifts up her face in a pseudo-elegant look seen in lost profile. She is not looking at the candle, nor at the skull she holds, nor at the jewellery she has cast on the floor. Three authentic *Magdalen*s by La Tour

Detail: blouse from Los Angeles *Magdalen.*

Detail: blouse from Washington *Magdalen.*

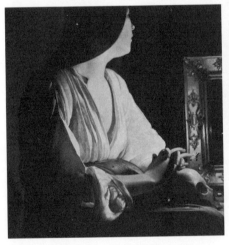

Detail: blouse from Metropolitan Museum's *Magdalen.* Compared to the other blouses, this 'cleavage' neckline seems vulgar and reminiscent of 1950s fashion.

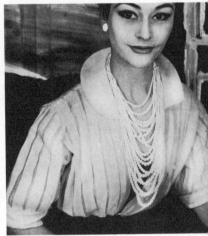

Blouse by Dior, as pictured in *Vogue.*

survive: two very similar to one another, in Los Angeles and the Louvre, and a third in the National Gallery in Washington. All three are characterised by a brilliant intensity of mood which is enhanced by the fact that in each picture the Magdalen is a figure in deep contemplation instead of being posed in a 'fetching' way.

The painter of the Wrightsman *Magdalen* has placed his model in a 'La Tour' position without requiring her to take on a seventeenth-century attitude. Her blouse displays a plunging neckline in a manner far too reminiscent of film stars in the Marilyn Monroe mould.

The picture's weaknesses do not end there. The jewellery thrown on the ground is an idle copy of that seen in Caravaggio's *Magdalen* in the Galleria Doria Pamphilij, Rome, in which picture the discarded baubles are at least wearable. In the 'La Tour' they are indeterminate heaps of glitter, just as are the pearls piled up on the table. The incompetence does not end there. My observations on the inadequacies and incongruity of the mirror frame have already been referred to when I first noticed them. The candle flame is seen duplicated in the mirror but with a strange perspective. We have, yet again, to accuse poor La Tour of more incompetence if we are to continue to accept that he painted it.

It seems to me much more likely that *The Magdalen* was painted in the years just before 1960, with the intention of passing it off as a La Tour. In support of this there is the very curious picture surface. Parts of the lighter areas are characterised by a bubbling of the paint quite in keeping with the picture having been subjected to the close application of heat, rather than being damaged by a fire. One ageing method known to forgers is the careful use of a hair dryer to crack the paint. The picture betrays in no part of its surface evidence of La Tour's brilliant draughtsmanship or subtle lighting. It is a fitting irony that at the time of writing it hangs in the same room in the Metropolitan Museum as *The Fortune Teller*.

Whoever painted *The Magdalen* had no stylistic relationship with the painter of the Louvre *Cheat* or *The Fortune Teller*. M. Landry, however, produced two more pictures in the 1972 exhibition, which were candlelit, with some claim to be related to La Tour. The first was generally dismissed. It was a copy of a

lost original, depicting a composition rather similar to the then recently discovered *Dice Players* from Middlesbrough. This upstaged M. Landry's picture, which was relegated to the study section of the exhibition. There also appeared, as M. Landry's property, a *Head of a Woman* which had been attributed to La Tour by Vitale Bloch as far back as the 1930s. Ben and I thought that this head was a fragment of a lost painting by La Tour. It was covered in heavy craquelures familiar to connoisseurs as signs of ageing in a picture, but very easily imitated

M. Pierre Landry has not granted permission to reproduce this picture despite repeated requests over a period of time.

Head of a Woman. 37.5 × 28 cm. Landry Collection, Paris.

by forgers. Any re-examination of this picture is likely to bring it under suspicion as a La Tour simply on grounds of weakness. Mr Sidney Sabin, on examining a photograph of the picture, was extremely unhappy about it.

Stripped of so many forged and wrongly attributed pictures, the art of Georges de La Tour gains greatly in stature. In this revision of the base on which his work has been reconstructed not one single masterpiece has been lost. La Tour's reputation will surely rest on the still, calm, candlelight pieces such as the Rennes *New-born*, the Nantes *Dream of Joseph* and the Louvre *Christ in the Carpenter's Shop*. It is almost two hundred years since the *New-born* was first noticed, and over one hundred and seventy years since *The Dream of Joseph* arrived in the Nantes Museum. Not one of these pictures, known for so long, has been demoted. Instead their stature has grown since the number of authentic candlelight pictures securely attributed to La Tour is now less than twenty.

CHAPTER 7

A whole group of forgeries is identified.

AS IT HAS NOW been established that in my opinion *The Cheat* was painted sometime in the 1920s it is necessary to make a more detailed analysis of this now remote period.

The upheavals of the first world war in Europe brought a very large number of old master pictures onto the art market at exactly the time that the newly-made fortunes in America were eager to buy prestigious works of art. The dealer Duveen, supported by Berenson as his 'expert', went a long way towards supplying this need. It is only in very recent years that criticisms have been levelled at both men as it becomes more and more apparent that the unsound basis of some of Berenson's attributions were very much for Duveen's benefit.

The sheer quantity of art market purchases in the 1920s made it a relatively normal matter for pictures without adequately researched provenances to be snapped up by all-too-eager collectors and museums. What also happened very often was that private collectors without adequate expertise bought pictures which were then given or bequeathed to public collections a generation later. The position of such pictures is all the more impregnable because it is extremely distasteful to have the very foundations of the collection of a generous benefactor challenged.

My own search for problem pictures was guided in two ways. I was extremely methodical in recording the comments of other scholars when it came to the relationship of *The Fortune Teller* to other works of art *not* by La Tour. On the other hand it was beyond the power of any individual to search through the whole of Western European Painting in the hope of coming up with forgeries. However I had the advantage of studying in great detail three problem pictures (the two *Cheats* and *The Fortune Teller*) in my opinion now by different hands. It would therefore strike me immediately if I came across any similar pictures of whatever school or period. The locations of such

searches were easy enough. If my hypothesis was right the forgeries I was looking for would only be found in collections brought together in the first thirty years of this century for pictures related to the Louvre *Cheat* and in the 1940s and 1950s for *The Fortune Teller*. Furthermore such problem pictures would only be found in collections which had spent large sums of money in their time.

Inevitably I first began to look for 'seventeenth-century' pictures, which were easy enough to identify. One of the most glaring was a so-called Frans Hals *Portrait of a Man* in the Fine Arts Museums of San Francisco. I wrote to the museum concerned asking for information and received no satisfactory reply. This picture is especially important in identifying the activity of a forger because it bears no real resemblance to Frans Hals. The background is light in tone and the sitter has an unconvincing projection of hair to the side and back. His costume is especially elaborate and there is an unmistakeable treatment of criss-crossing brushstrokes used to create the effect of textile. With this I was all too familiar: the brushwork was similar, if not almost identical, to that found on the collar of the second figure from the left in *The Fortune Teller*.

My curiosity aroused, I showed a photograph of the picture to Patrick O'Connor. His reaction was quick enough: 'Why that is a self-portrait of M. Delobre, the uncle of M. Dion' he exclaimed. It now became clear that the existence of Delobre as a possible forger had to be investigated. It was Brian Sewell who noticed that Delobre was listed in the standard dictionary of painters in French known as the Bénézit. The biography was brief enough, stating that he was born in 1873 and that he was *a copyist of the old masters*. As he died in 1954, he was still alive as an old man for O'Connor to remember him. It would be interesting to know where all Delobre's copies are now, seeing that not one of them has been identified. In the light of what we know of Delobre's employment by Nathan and Georges Wildenstein, having been spotted by Nathan *as a copyist*, it would be foolish not to consider at least the possibility that his works include many now hanging in major galleries as old masters, with the full knowledge of these two employers. Delobre must now be considered as a prime suspect for the authorship of *The Fortune Teller*.

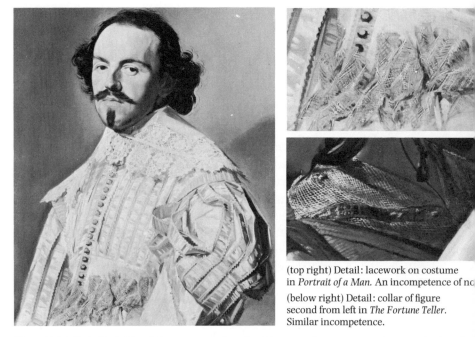

(top right) Detail: lacework on costume in *Portrait of a Man*. An incompetence of no

(below right) Detail: collar of figure second from left in *The Fortune Teller*. Similar incompetence.

'Frans Hals', *Portrait of a Man*. 66.3 × 57.2 cm. Fine Arts Museums, San Francisco. If moustache, beard an projecting tufts of hair were removed, would we be left with a self-portrait of the forger?

The relationship between the San Francisco 'Frans Hals' and *The Fortune Teller* is undeniable on stylistic grounds, and no evidence has so far been forthcoming to the effect that it is a genuine seventeenth-century picture. For this to be so we would have to rewrite art history with the suggestion that La Tour and Frans Hals were somehow stylistically related. Fortunately the greatest living authority on Frans Hals, Professor Seymour Slive, has rejected the San Francisco picture as a Frans Hals (without proposing an alternative attribution).

Armed with this chance similarity my next line of enquiry was to look very deliberately at other pictures possessed by owners of known problem pictures. If they were unlucky enough to have purchased one forgery, the forger might have tried to sell them more. M. Landry's most spectacular picture apart from *The Cheat* is a *Concert* attributed to three contemporaries of La Tour, the Le Nain brothers. It was lent by M. Landry to the exhibition held at the Grand Palais in Paris in 1978 where all the significant works of the La Nain brothers were brought together. The *Concert* was placed in the section of

attributed (i.e. uncertain) pictures although he was permitted to add a few sentences on his own picture in the catalogue. It is partly based on a perfectly genuine Le Nain studio picture housed in the reserves of the Dulwich College Picture Gallery.

In the *Concert* it is easy to see that there have been significant additions, which concern the more middle-class figures in the foreground. M. Landry commented on the dual nature of the artist's approach. In terms of seventeenth-century painting and in the context of the work of the Le Nain brothers, it would be highly unusual to mix the peasantry with a wealthier class. As usual with these problem pictures, we have to suspend our judgement over an important point. What challenges this picture as being a work of the Le Nain brothers is the similarity of the model on the right of his picture, the part changed from the Dulwich composition, to that found in *The Cheat*.

It could just be argued that the appearance of a similar model in a Le Nain and a La Tour was possible because they were contemporaries. However the handling of the paint in the feather headdresses seen in both pictures is virtually identical and yet *different* from the picture which inspired them both, the Fort Worth *Cheat*.

In other words the so-called Le Nain is an attempt by a painter familiar with *The Cheat* to weave into the art of the Le Nain brothers a picture with some La Tour-like elements. Exactly as in *The Cheat*, it is based on another composition, in this case the picture at Dulwich.

I came across a photograph of a picture owned by M. Landry in the files of the Rijksbureau voor Kunsthistorische Documentatie in The Hague. It was a particularly poor attempt at a Rembrandt *Self-Portrait* from his Leiden period in the late 1620s. It was exhibited at Leiden in the 1950s as M. Landry's property and has, from the photograph, the same curiously arched eyebrows familiar from the La Tour forgeries.

In trying to ascertain the origin of these pictures little information has come to light. We know that Monsieur Landry bought his *Cheat* from a private house on the Quai Bourbon in Paris in 1926. The Le Nain *Concert* was sold at the Galerie Charpentier in the 1950s, and the Rembrandt had no particular provenance. These pictures were not from old and well-known collections.

M. Pierre Landry has not
granted permission to
reproduce this picture despite
repeated requests over a period
of time.

'Le Nain Brothers', *Concert*. 77 × 87 cm. Landry Collection, Paris.

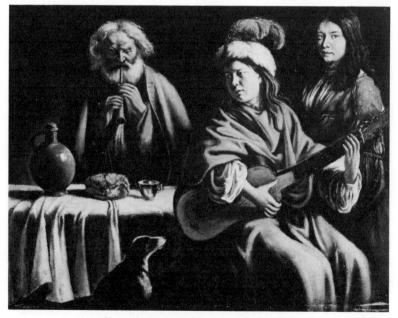

Follower of Le Nain Brothers, *Concert*. 30.5 × 39.4 cm.
Dulwich College Picture Gallery.

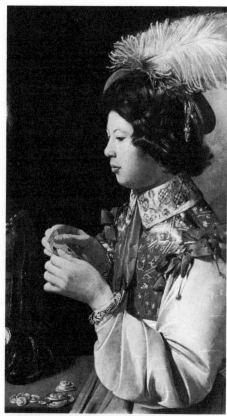

Detail: dupe on right, Louvre *Cheat*.

M. Pierre Landry has not
granted permission to
reproduce this picture despite
repeated requests over a period
of time.

Detail: figure on right, Paris *Concert*.

M. Pierre Landry has not
granted permission to
reproduce this picture despite
repeated requests over a period
of time.

(above) Detail: feather from figure on right, Paris *Concert*.

(above right) Detail: feather in dupe's hat, Louvre *Cheat*. Compare the handling with that below.

(right) Detail: feather in dupe's hat, Fort Worth *Cheat*.

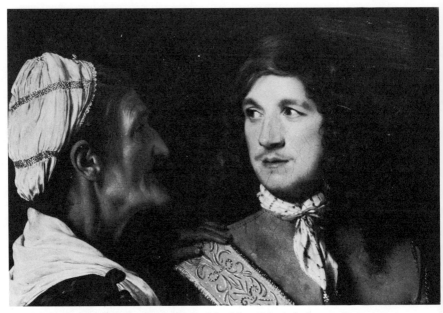

'Michel Sweerts', *The Procuress*. Copper, 19 × 27 cm. Musée du Louvre, Paris.

The relationship of the San Francisco 'Frans Hals' to *The Fortune Teller* and the Le Nain *Concert* to *The Cheat* are my stylistic analyses. With *The Procuress* in the Louvre attributed to Michel Sweerts we are on even safer ground because the authorities of the Louvre admit that it is related to *The Fortune Teller*. The Louvre bought the picture in 1969 and attributed it to a Dutch painter almost as rare and as enigmatic as La Tour, Michel Sweerts. The artist had a short career which extended from an early period in Brussels to a precocious development in Rome, an early maturity in Amsterdam and death about the age of forty at Goa in Portuguese India where he had become a missionary.

Sweerts has become an ideal candidate for both wrong attribution and forgery as his style was so enigmatic. In the Louvre picture we have an already familiar sight: an old crone and a young cavalier. The picture first appeared in a Rome sale in 1910 where it was attributed to the well-known Dutch genre painter, Gerard Terborch. This provenance was especially difficult for me to trace, as when the Louvre authorities published the picture's history at the time of its acquisition they made a mistake, stating Florence instead of Rome.

The old crone is close indeed to the familiar image in *The Fortune Teller*, as is the young cavalier. Round his neck in the Sweerts the cavalier wears a striped scarf similar to that worn as a turban by the prostitute in *The Fortune Teller*. These similarities were pointed out by the Louvre without the slightest attempt to explain how it was that La Tour, isolated in Lunéville, could have been familiar with the work of the much-travelled Sweerts.

As the history of the painting now goes back some seventy years it is necessary to search for similar pictures known at the time. As might be expected there exists in a Dutch Private Collection (which I have not seen) a similar composition in which the figures are shown much longer. In other words we have the already familiar characteristic of adaptation from an existing composition. Hence the resemblance to the 'La Tours', because they are likely to have been painted by the same artist. It seems probable that the Louvre Sweerts is one of Delobre's 'copies' which found its way into a saleroom as long ago as 1910. It then went up the art market spiral to be attributed to Sweerts, and finally arrived in the Louvre almost sixty years after it had been discovered.

One of the other fruitful areas for forgery has been the art of Nicolas Poussin. Poussin's art is unusually well documented for a seventeenth-century painter, and a very high proportion of his compositions were engraved either in his own lifetime or soon after his death. This was a great help for the historian seeking to establish the canon of Poussin's work and also a great invitation for the forger to fabricate a lost picture or one which was only known from an engraving. This is exactly what happened. In 1967 Blunt's monumental three-volume book on Poussin appeared and received wide scholarly acclaim. All the reproductions in it were a rather hazy black-and-white, and my own observations on the artist had to wait until I had travelled enough to have seen the majority of his two hundred surviving pictures. In doing this I came across a good number of problem pictures accepted as authentic by Blunt. It was only after becoming preoccupied with *The Fortune Teller* that I began to search through Poussin's work to see if any of the problem pictures fitted into the now familiar pattern.

The most painful picture, now rejected by all the Poussin

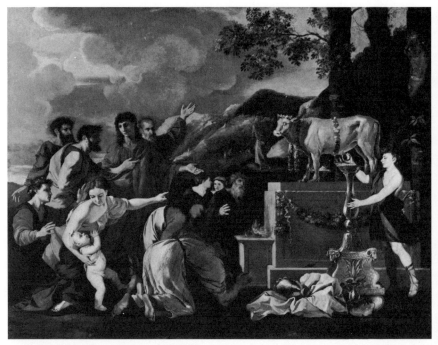

'Nicolas Poussin', *Adoration of the Golden Calf.* 99.4 × 128.6 cm. Fine Arts Museums, San Francisco.

'Nicolas Poussin' *Two Heads*, fragment from *Adoration of the Golden Calf.* 32.5 × 45.5 cm. Private Collection, London.

authorities, was the *Adoration of the Golden Calf* in the Fine Arts Museums of San Francisco. The picture had been known since the early 1920s, although it had been acquired by the museum much later. The attribution to Poussin was upheld by Blunt in his book and the picture bore, uniquely for Poussin, a signature and a date 1626. This was accepted without question by Blunt, who used the picture as part of his complicated arguments for building up the early chronology of Poussin's pictures. The picture was in fact based on the engraving of Poussin's composition. It is likely to have been painted by the artist familiar with *The Cheat*, especially in the treatment of the staring eyes of the figures in the background.

If this picture were the forgery I believe it to be it should exist in isolation in Poussin's work. Fortunately for my hypothesis Blunt himself identified one further picture close in style which he attributed to Poussin as well.

This new picture is the most significant of the problem pictures in this group for a variety of reasons. It consists of just two heads.

It requires no complicated argument to note that the profile in the so-called Poussin is not unlike the profile in *The Fortune Teller*. Further examination of the 'Poussin' is extremely revealing, both in terms of its recent history and the results of the technical analysis conducted by Professor Rees-Jones at the Courtauld Institute.

Detail: faces in background,
Adoration of the Golden Calf.

Detail: profile,
Two Heads.

Detail: profile,
The Fortune Teller.

X-ray of *Two Heads*. The diagram shows how the picture formed part of a larger canvas, turned on its side. The X-ray clearly reveals a building like the Colosseum and other details painted at right angles to (and underneath) the *Two Heads*.

The painting first appeared in a Christie's, London, sale in 1944 as coming from the collection of the Earls of Carlisle. It passed very soon after into the Liddell family collection where it was identified by Blunt as a fragment of a picture which had been damaged by rioting in the seventeenth century. On the death of David Liddell the picture passed to his younger brother Guy Liddell. It was revealed by the Press some time ago that Guy Liddell had been the head of MI5 at the time when Blunt was spying for the Russians. Furthermore, according to the statement made by the late Goronwy Rees to Andrew Boyle, it was Liddell who refused to believe in Blunt's activity as a spy even after Rees had denounced him. It is therefore a matter for speculation as to what was the real relationship between Blunt and Liddell, bearing in mind that Blunt had been advising the Liddell family to acquire a so-called Poussin.

The X-ray examination of the picture reveals a familiar problem. The picture is painted over another quite different composition which was both much larger and at right angles to it. The picture underneath, which is clearly visible in the X-ray, was an elaborate architectural landscape with a building closely resembling the Colosseum in Rome.

Any attempt to extend the Poussin in its logical direction, bearing in mind that heads of this scale would be at the top of such a composition, results in making the landscape in the other direction highly improbable.

It was with considerable surprise and great interest that I noted that in the Poussin exhibition held in 1981 at the National Gallery of Scotland in Edinburgh, the Liddell provenance was not mentioned when all the other pictures in the exhibition were given their full histories; and that nobody noted the problems posed by the X-ray.

In other respects the picture runs true to form as a forgery. We only have to look as far as Poussin's *Bacchanalian Revel before a Term of Pan* for the source of the figure looking straight at us in the *Two Heads*.

It is interesting to see how Blunt reacted over the years following his book on Poussin of 1967. In the light of every other authority's point of view he came round to deciding that the San Francisco *Adoration of the Golden Calf* was not by Poussin. He never explained what he thought its status was

Detail: face, *Two Heads*. Detail: face (reversed) from Poussin,
 Bacchanalian Revel before a Term of Pan.

(considering its signature and date), and significantly continued to uphold the authenticity of the *Two Heads*, forgetting that the two pictures stand or fall together.

The whole group of pictures so far discussed is in my opinion from the same stable, most of them going back to the 1920s with the exception of the Louvre Sweerts (1910) and *The Fortune Teller*, which is rather later on stylistic grounds. This conclusion will hardly be welcomed by the respective owners of the pictures. They do, however, fit together as a coherent group, cutting across artists of different nationality working in the same period. They all provoke *academic* comment but not one of them, with the single exception of *The Fortune Teller*, has ever caught the public imagination or can be termed as a significant work of art.

When Brian Sewell interviewed Dion in Corsica, there were in the studio a number of pastiches of Flemish fifteenth-century pictures, all of them in Sewell's opinion of very poor quality. When I questioned O'Connor on the point he said that in his recollection it was Delobre who was the specialist in painting pictures in the style of the fifteenth-century Flemish masters. Again I was faced with the difficulty of going through the corpus of surviving fifteenth-century Flemish pictures concentrating only on those works which had appeared in the early

part of this century. I was helped by the fact that the number of pictures surviving and artists active was very much smaller than in later centuries.

I had to find pictures which could be related to either *The Fortune Teller* or the Louvre *Cheat* which were attributed to fifteenth- or early sixteenth-century Flemish Masters. The premise on which an art historian works is that however much a particular painter tries to change his style he will always give himself away by certain little tricks of 'handwriting'. Our painter of *The Cheat* and *The Fortune Teller* had a number of very obvious characteristics. There was a love of elaborate detail, especially in costumes. There was a lack of psychological penetration, and a preference for sideways glances curiously reminiscent of film stills. The technique of handling the paint was usually flawless but the drawing bad. Weakest of all was the sense of period. It was the anachronistic approach to the subject-matter which most disturbed me about the pictures I had so far discovered.

The early part of this century was a period of revival of interest in Flemish fifteenth-century painting. Most of the masterpieces of the period had always been acknowledged. The Van Eyck brothers' Altarpiece in St Bavon in Ghent had been famous since it was completed in the early 1430s. To this day Van Eyck's *Arnolfini Marriage* remains one of the most popular pictures in the National Gallery in London. As might be expected, the distribution of the pictures of this period was in a few great old collections, especially in Belgium where the artists had worked, and in Spain because the Spanish had collected and commissioned work from the artists when they controlled the Netherlands. Important collections had also been built up, mostly in the nineteenth century, by the museums of Berlin, Paris (Louvre) and the National Gallery in London. In other words at the dawn of the present century, in spite of the revival of interest, there was a conspicuous *shortage* of important pictures from the period. Almost all the main artists worked extremely painstakingly and the number of surviving pictures for each artist sometimes numbered as little as twenty, with some painters such as the 'Master of Moulins', and Geertgen tot Sint Jans, far fewer. It was to these painters' work that I turned, especially as their reputations had been revived after 1900.

With hindsight it almost seemed too easy. In the Wallraf-Richartz Museum in Cologne there is a *Portrait of a Man* which bore an attribution to the incredibly rare Dutch artist Geertgen tot Sint Jans who worked, it is believed, in Haarlem in the last years of the fifteenth century. (His few surviving pictures are distributed between the museums of Vienna, Prague, Paris, Rotterdam, Amsterdam, Utrecht and London.) The attribution to Geertgen is no longer upheld by the authorities of the Cologne Museum and according to their most recent catalogue it is attributed to a later 'follower'.

The picture appeared on the English art market in the 1920s and is without any previously recorded history. What gave the picture away as being by the same artist as *The Cheat* was the characteristic treatment of the man's hand.

Looking again at the Cologne picture as a whole, the eyes with their slightly staring look take on a familiar cast. They certainly bear no resemblance to the esoteric art of Geertgen, whose best-known picture is the tiny *Nativity by Night* in the National Gallery, London. The Cologne picture also contains the elements of a joke, although at the time it was painted I suspect that it was merely an anachronism. The worthy burgher (the sitter is a member of the professional classes to judge from his costume) is carrying over his shoulder a staff which bears close resemblance to a golf club. In the seventeenth century the Dutch did indeed play a form of hockey (which was called kolf) and they used a curiously formed stick to do it. It seems reasonable to assume that the game existed earlier, even in Geertgen's time. The forger's mistake, therefore, was not the actual introduction of such a bizarre object but the *way* in which the man was carrying it over his shoulder, as if it were a pikestaff. Such an attitude is impossible in a painting of the time, as it is clearly intended to be a formal portrait.

Inevitably there are similar pictures executed in the same style. One such work is in the collection of Baron Thyssen at Lugano. It is there attributed to an anonymous Nuremberg painter because the old attribution to Albrecht Dürer can no longer be upheld. Indeed the Thyssen collection, unlike those of some private owners, upholds the highest scholarly standards.

Again as in the 'Geertgen', there is the familiar staring look in the eyes and the familiar chubby hand, which in this case is

'Geertgen tot Sint Jans', *Portrait of a Man*. Panel, 35 × 26 cm. Wallraf-Richartz Museum, Cologne.

'Nuremberg School', *Portrait of a Woman*. Panel, 49 × 39.8 cm. Thyssen Collection, Lugano.

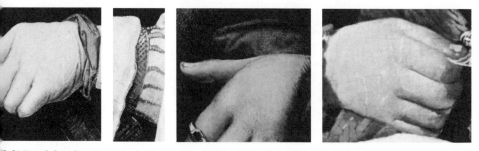

(left) Detail: hand, in *Portrait of a Man*. (centre left) Detail: cuff, in *Portrait of a Man*. Does the handling of the criss-cross strokes resemble that of the collar in *The Fortune Teller* and on the 'Hals' costume, p. 134? (centre right) Detail: hand, in *Portrait of a Woman*. (right) Detail: hand, in Louvre *Cheat*.

partly cut off along the bottom. What is especially clumsy and disconcerting in the Thyssen picture is the treatment of the woman's bodice, which has no particular form of fastening: exactly the same problem as in *The Fortune Teller*.

The Thyssen collection has to avoid the attribution to Dürer, to whose work it bears only a superficial resemblance. The picture now is given to an anonymous contemporary of Dürer in Nuremberg from whose hand no other such pictures have

survived. My own answer is the simpler one: although as a Nuremberg object it is unique, as a Delobre it is all too familiar. It surfaced as from a 'French Private Collection' in 1935.

I strongly suspect that there are a considerable number of these 'portraits' around attributed to a host of different masters all betraying 'unique' characteristics for their times. They are extremely difficult to spot without systematic analysis and constant comparison with the apparent sources in *The Cheat* and *The Fortune Teller*.

If Geertgen tot Sint Jans can be considered esoteric (but none the less valuable in commercial terms) then the 'Master of Moulins' is the most obscure of them all. This name is given to a still anonymous and probably Flemish master who produced one dazzling masterpiece – an altarpiece in the cathedral of Moulins in Central France. Round this have been grouped a small number of pictures which have sometimes been identified as from the hand of a certain 'Jean Hey'. This 'Master of Moulins' was rehabilitated in 1904 at the time of the exhibition in Paris of French masters of the fifteenth century. The candidate is one of the most bizarre of all the pictures in this group of forgeries. It was bought by the National Gallery in London from Agnew's in the 1920s with an attribution to the 'Master of Moulins'. It was considered to be the right half of a diptych, the other panel, an *Annunciation to the Virgin*, being in the Art Institute of Chicago. Fortunately, exactly as in the case of the Geertgen, the National Gallery has now designated the painting as by a 'follower' of the 'Master of Moulins'.

The painting depicts, according to those learned in iconography, St Joachim embracing St Anne, with Charlemagne before the Golden Gate. What renders the picture merely silly is that the Virgin's parents were indulging in what can only be described as a smooch. Carefully ignoring them is an impassive and extravagantly dressed Charlemagne (Crowned Holy Roman Emperor in AD 800). Behind them is a Gothic and Renaissance pile designated as 'The Golden Gate'.

The picture should in any case be dismissed as a curiosity but what caught my attention was some all-too-familiar handling of the paint. There is a very narrow strip down the right hand side of the picture which is a badly painted piece of patterned textile. The old crone's shawl in *The Fortune Teller* immediately

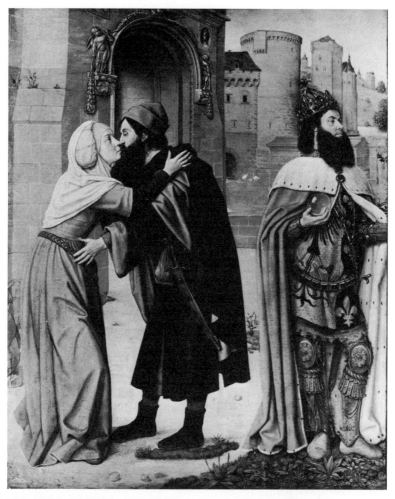

'Master of Moulins', *St Joachim embracing St Anne*. Panel, 71.8 × 59.1 cm.
National Gallery, London.

(left) Detail: costume of Charlemagne in *St Joachim
embracing St Anne*.

(right) Detail: collar of cavalier in *The Fortune Teller*.
The same crude handling of similar simple patterns?
See also the serving maid's collar, Fort Worth *Cheat* (p. 122).

springs to mind. This may be seen as a coincidence but what is
surely not a coincidence is the funny patterned decoration of
Charlemagne's armour. It is made up of a series of little
diamonds as on the collar of the youth in *The Fortune Teller*.
Even more disconcerting is the further similarity of the pattern

to that on the trimmings of the serving maid's dress in the Fort Worth *Cheat*. Are we yet again, therefore, required to suspend our judgement and common sense and suppose a link between an 'anonymous' 'follower' of the 'Master of Moulins' and Georges de La Tour, or are we viewing, yet again, one of Delobre's skilful hoaxes?

My next candidate for research was the work of Petrus Christus, the talented pupil of Jan Van Eyck. Exactly as for the 'Master of Moulins' and Geertgen, the works of Petrus Christus are excessively rare, some dozen being accepted by all authorities. Unlike the other two artists, however, Petrus Christus formed part of the mainstream of painting in the 1440s in Bruges following the death of Jan van Eyck. It would, therefore, be very much more difficult to insert a totally successful 'Petrus Christus' into this very tightly-knit area.

The *Portrait of a Couple* in the Lehman Collection in the Metropolitan Museum, New York was first certainly recorded about 1900 and was dated 1444. It had always been used by modern scholars as the lynchpin of the reconstruction of the artist's development because, uniquely, it bore a date.

As the Lehman picture is a *Couple* apparently at the point of betrothal, there is at least an important precedent painted by Petrus Christus's master only ten years before, the *Arnolfini Marriage* in the National Gallery, London. It is therefore easy to see that the 'Petrus Christus' is quite out of keeping with the mood of the period by its very casual quality. What characterises the whole of fifteenth-century Flemish art is attention to formal qualities. People in portraits were *never* shown in acts of intimacy or even relaxation.

In putting his 'Petrus Christus' together the painter made various mistakes. The mirror on the right presents a view it could not reflect, and fails to offer the necessary distortion. Curiously enough, the Louvre's celebrated Quentin Massys, *The Moneylender and his Wife* of 1514 (half a century after Petrus Christus) shows many similar elements, including a circular mirror with appropriate perspective. What makes the 'Petrus' a probable Delobre, and an early one (as he was born in 1876), is the fact that the couple are displaying the familiar heavy-lidded glance.

The best known of this group of pictures which I consider to

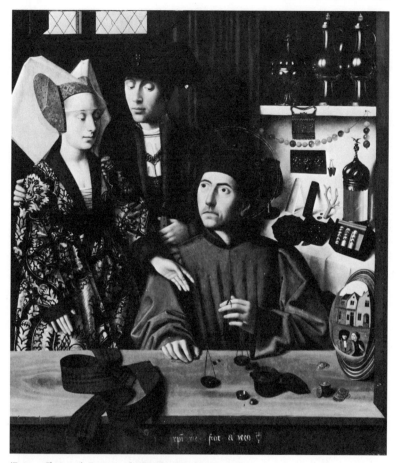

'Petrus Christus', *Portrait of a Couple*. Panel, 99 × 85 cm.
Lehman Collection, Metropolitan Museum, New York.

be later than the fifteenth century is a 'Rogier van der Weyden'
bought by the National Gallery in London in 1971 for a large
but undisclosed sum. Apart from Jan van Eyck, van der Weyden
was the most distinguished painter of the time and the National
Gallery lacked an important work by him, even though it was in
possession of significant pictures attributed to his master Robert
Campin.

According to the article on the picture published in *The
Burlington*, the painting was identified in the outhouse of an
undisclosed lady of title in about 1970 by the late David Carritt.
At the time of the purchase by the National Gallery the picture
puzzled me and I remember asking Ben about it. It was he who

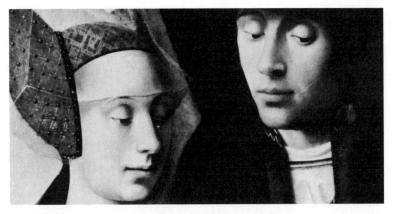

Detail: faces in *Portrait of a Couple*. Compare with face opposite.

remarked that the paper the Saint was reading consisted of many lines of meaningless inscription. What was happening in the picture was curious enough. It is supposed to depict St Ivo, the patron saint of lawyers, reading a paper. The face is clearly a portrait, made more obvious by the appearance of a small scar. To be convincing as an object from the period it would have to be the portrait of a particular sitter in the garb of St Ivo. Where the picture falls down, in spite of its flawless technique, is the fact that the 'Saint' is reading those lines of nonsense. It is entirely out of keeping with the mentality of the times to make a seriously minded saint perform such an act. In the fifteenth century the inscription would have intelligibly recorded a very specific point. When this element of the picture is taken into account, it becomes very difficult indeed to insert into the authentic work of Rogier van der Weyden. The man's face, with its slightly unshaven look, has a distinctly 'modern' look rather than a fifteenth-century one. The eyes in particular give the painter away. The perfectly tonsured hair could almost be a copy of that in a genuine work by Petrus Christus, *Portrait of a Carthusian* in the Metropolitan Museum, New York.

In bringing all these pictures together as a group, the fifteenth- and seventeenth-century ones have a good number of other characteristics in common. Almost all have been given 'respectable' but vague provenances. The Cologne 'Geertgen' was sent into the saleroom by a cleric from Earls Colne in Essex. The National Gallery 'van der Weyden' an unnamed aristocrat, and *The Fortune Teller* the aristocratic de Gastines family (M.

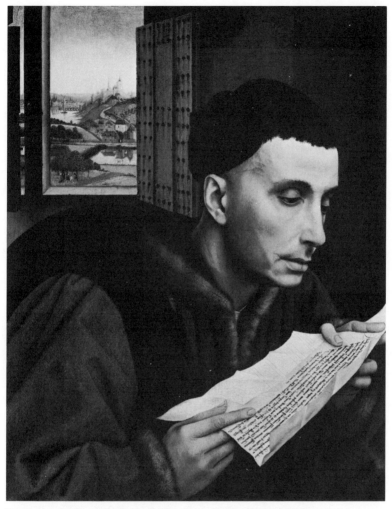

'Rogier van der Weyden', *St Ivo*. Panel, 45.1 × 34.8 cm. National Gallery, London.
Note the incorrect perspective of the left-hand margin of the 'writing'.

Celier was described as a count by Edwin Mullins). The other
pictures appeared on the market discreetly without arousing
any obvious suspicions. Their second common characteristic is
that not one of them existed in nineteenth-century or earlier
literature. A document of 1879 was produced apparently for
The Fortune Teller in 1981. Not one of these pictures aroused the
interest of any writer or art critic in the nineteenth century or
earlier. It is my contention that this is because they did not
exist. Not one of these pictures can be described as part of

cultural history in the proper sense. They do form part of twentieth-century cultural history in the sense that, at best, they reflect present-day interpretation of the past.

It is perhaps even more surprising that a very high proportion of the pictures in the group I have named have been demoted by their owners from the old attribution without going so far as to suggest forgery: the National Gallery in London with its 'Master of Moulins', Cologne with its 'Geertgen', San Francisco with its *signed and dated* 'Poussin' and its 'Frans Hals'. There is on the other hand a much greater reluctance to make these changes of attribution when a large sum of money has been spent in recent years – hence the Louvre's 'Sweerts' and *The Cheat*, the Metropolitan Museum's *The Fortune Teller* and the London National Gallery's 'van der Weyden'. Collectively these pictures represent the spending of many millions of public or public benefactor's money. Some institutions have behaved correctly by demoting pictures but they rarely do this with the same publicity they accord expensive new acquisitions.

The Metropolitan Museum, however, always publicity conscious, called *The Fortune Teller* (in 1982) 'The World's most controversial painting', as if admitting that something might be thought wrong with the picture.

Many people will be shocked by the allegations I have made against the pictures discussed in this book. Inevitably I have already come into conflict with museum officials defending their 'property' or dealers anxious that transactions effected in the distant past by long dead employees or owners should not reflect on their present reputations. In my own experience of the present-day art world I have witnessed cases where a totally spurious picture has been accepted in good faith. On enquiry it usually turns out that a whole series of mistakes have been made, each one bigger than the last. Blunt and others have turned a blind eye, and have persuaded and forced others (including myself) to do the same, knowing full well that Georges Wildenstein was anxious not to have certain pictures questioned. He meanwhile was using his position to 'launder' the reasonably talented works of Delobre and pass them off as the works of lesser-known old masters. This was, I feel sure, the production-line of forgery on which I accidentally stumbled, and which must finally have ended with the deaths of Delobre

and Georges Wildenstein. These things, it must be said, have nothing to do with the business of the present-day company which bears the name Wildenstein. No doubt in some quiet studio even now, there is another Delobre working for some other master in another part of the world, serving up new masters for old. Yet my concern has always been with the works of art rather than with those supplying or owning them.

The acceptance of a forgery as genuine is by its very nature an individual mistake and not a conspiracy. It is the defence rather than the investigation of authenticity after challenge which has had the atmosphere of people anxious not to know. It is no use the Metropolitan Museum trying to defend their picture by invoking the authority of the Louvre, or any other institution. Pictures must stand or fall on their own merits. On that score all the paintings named in this book as forgeries come out badly indeed. They are the playthings of art historians, shifting backwards and forwards from decade to decade (La Tour) or from artist to follower (Geertgen, Master of Moulins) or suffering downright rejection (Poussin, Frans Hals). They are not loved by the public spontaneously as great works of art. If they were all consigned to the flames tomorrow their loss would hardly be noticed. A whole range of great painters would have their work purged of the dross with which they have been corrupted.

CHRONOLOGY OF THE APPEARANCE OF THE PAINTINGS DESCRIBED AS POSSIBLE FORGERIES :

c. 1900 Earliest appearance of the signed and dated *Portrait of a Couple* by Petrus Christus, later in the Lehmann collection and bequeathed to the Metropolitan Museum, New York.
Unique in the artist's work in bearing a signature and a date.

1903 First appearance of the Master of Moulins' *St Joachim embracing St Anne* in a French Private Collection. Bought by the London National Gallery from Agnew's in 1925. Subsequently demoted by the gallery to 'follower of'. Stella Newton dated the costumes later than the artist's known period of activity.

1909/10 Delobre hired by Nathan Wildenstein.

1910 *The Procuress*, then attributed to the Dutch genre painter Gerard Terborch, appeared in the Elia Volpi Sale in Rome, 3 May 1910 where it was illustrated in the catalogue as No.217. Bought by the Louvre, Paris in 1967 as by Michel Sweerts. In 1971 compared by them to *The Fortune Teller*.

1919 *The Adoration of the Golden Calf* after an engraving by Poussin was exhibited at the Sackville Gallery, London as having come from the collection of the Earl of Harewood. Bought by the San Francisco Museums in 1955 as by Poussin and supported by Anthony Blunt. He later changed his mind along with all other scholars. Unique in the artist's work in bearing a signature and a date.

1923 First appearance of the *Portrait of a Man* when published by Rudolph Valentiner as by Frans Hals. Later acquired by the San Francisco Museums. Demoted by Seymour Slive, the accepted authority on Hals.

1926 The *Portrait of a Man* appeared in the sale of Canon Sutton, of Earls Colne, Essex, at Christie's, London, 12 February 1926 (lot 21). Acquired by the Cologne Museum in 1940 as a work of Geertgen tot Sint Jans. Later considered by the museum to be by a follower.

1931 First publication of *The Cheat* in the collection of Pierre Landry, Paris. The signature of Georges de La

Tour was on the picture, thus giving birth to the controversial idea that La Tour could have painted 'daylight' scenes.

1932 M. Landry stated that he was aware of the other version of his picture, the Geneva *Cheat* now in Fort Worth.

1935 The Thyssen Collection acquired the *Portrait of a Woman* then thought to be by Dürer from a French private collection. It is now considered to be 'Nuremberg School' *c.* 1525.

1944 The *Two Heads* appeared in a London, Christie's Sale, 19 February 1944 with an attribution to Guido Reni. The picture was then attributed to Poussin by Blunt, who considered it to be a fragment of a painting which had been destroyed in a riot. The picture was acquired by the Liddell family, ending up with Guy Liddell, the head of MI5 at the time of Blunt's espionage.

1949 The *Concert*, attributed by M. Landry to the Le Nain brothers, appeared at an exhibition held at the Galerie Charpentier, Paris. At the time of the Le Nain exhibition held at the Grand Palais in Paris in 1978 the picture was not fully accepted as by the Le Nain brothers.

1954 Delobre dies.

1958 Dion restores a 'La Tour' painting depicting 'a young man being swindled in a brothel' (his description) in New York. Brian Sewell sees a similar painting in Paris.

1960 The Metropolitan Museum bought the previously unknown picture *The Fortune Teller*, now hailed as a masterpiece by Georges de La Tour. Only later did conflicting accounts of the picture's earlier history appear.

1971 The National Gallery, London, bought a hitherto unknown *St Ivo* at the time attributed to Rogier van der Weyden. The source stated was that it had been found in an outhouse belonging to a lady of title. The attribution to van der Weyden has not been universally upheld.

INDEX

Numbers in italics refer to illustrations